# Color Decoration & Illumination in Calligraphy:
## Techniques and Projects

Margaret Morgan

# Color Decoration

# Illumination

# in Calligraphy:

## Techniques and Projects

Dover Publications, Inc., Mineola, New York

**ACKNOWLEDGMENTS**

Grateful thanks for the loan of equipment for photography to:
L Cornelissen & Son, Mr Philip Poole, Falkiner Fine Papers, Daler Rowney,
Acco-Rexel, John E Wright, Nottingham (for Blundell Harling) and
R K Burt & Co, paper distributors; for permission to reproduce their
work: Gerald Fleuss, Gaynor Goffe, Ann Hechle, Donald Jackson,
Timothy Noad, Christine Oxley, Joan Pilsbury, Wendy Westover and
Nancy Winters; to Michelle P Brown and Scot McKendrick of the British
Library, London, for their enthusiastic encouragement and assistance with
both text and pictures in the history section; also to Dr Peter McNivern
and staff at the John Rylands University Library of Manchester;
Judy Walker, my editor; and to all who encouraged me along the way,
particularly Geoff who did much of the photography, as well as the typing,
Madge Rider who gave me my first nibs, and Roz Dace without whom
this book would not have happened.

In 'Centuries of skills' figs 2, 4, 6, 10 and 13 are reproduced by kind
permission of the British Library; figs 8 and 11 by courtesy of the Director
and University Librarian, John Rylands University Library
of Manchester.

Published in Canada by
General Publishing Company, Ltd.,
30 Lesmill Road, Don Mills,
Toronto, Ontario.

This Dover edition, first published in 1997, is an
unabridged reprint of the work originally published by
B.T. Batsford Limited,
583 Fulham Road
London SW6 5UA
It is published by special arrangement with the original
publisher.

Dover Publications, Inc.,
31 East 2nd Street
Mineola, N.Y. 11501

Library of Congress Cataloging-in-Publication Data

Morgan, Margaret.
    Color decoration & illumination in calligraphy /
    Margaret Morgan.
        p.     cm.
    Includes index.
    ISBN 0-486-29507-9 (pbk.)
    1. Calligraphy—Technique.   2. Illumination of books
and manuscripts—Technique.   3. Artists' materials.
I. Title.
NK3600.M67   1997
745.6'1—dc20
                                        96-41747
                                        CIP

# Contents

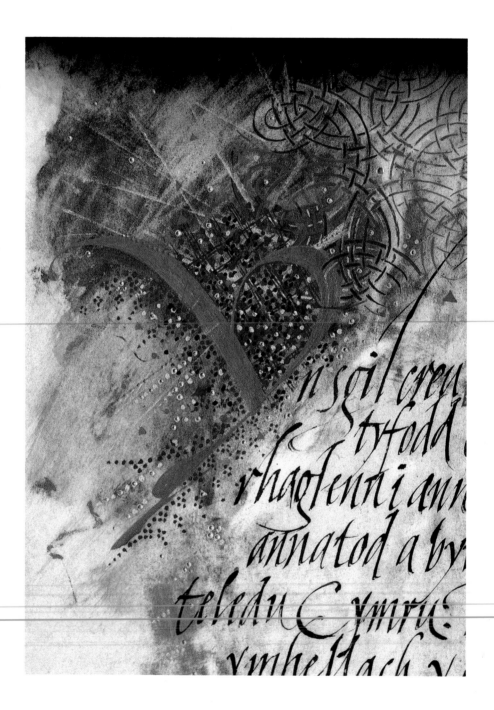

figure 1

Detail of calligraphy by Donald Jackson. Written in Welsh on vellum in gouache, stick ink and vermilion tempera with shell gold decoration, using goose and swan quills.

*See page 85 for full image.*

# Introduction

Simply expressed, illumination is the art of decorating books with colour and gold in order to tell a story and enrich the page. The word stems from the Latin *illuminare,* meaning 'to light up'. Miniature paintings, decorated capitals, borders and other embellishments in bright, strong colours, enlivened with gold, were used for centuries to produce startling effects which truly lit up the pages of the books. Most early books were religious in content and the depiction of scripture stories in historiated capital letters served to enhance the text and enlighten the reader – a mediaeval visual aid, perhaps.

You can use the same ideas to enhance your own calligraphy. There are many applications apart from manuscript books, including simple items made for yourself or as gifts for others, using skills and techniques similar to those of the early scribes.

This book begins with a brief history of illumination and decoration in the Western world, covering manuscript books produced between the late seventh century and the advent of printing in the fifteenth century. Significant periods of illumination and their accompanying calligraphy are included, and are designed to give you enough knowledge to make informed and tasteful choices of letter style and decoration in your own work.

A section on materials, both traditional and modern, is followed by a chapter on the basic techniques of writing, drawing and painting. This is accompanied by projects based on these techniques, developing from simple ideas to complex and ambitious schemes using several skills. The principles of design and layout are explored in the next section, followed by a section on floral borders. The techniques conclude with a section on gilding.

After the techniques and projects comes the Gallery, which contains work by modern scribes and demonstrates what can be achieved with practice and application.

When you have finished the book, you may like to re-read it, and apply the complex techniques to the simpler items. This way, you may progress with confidence and not be overfaced initially with difficult and demanding skills. My overall aim has been to convey the enjoyment derived from making something beautiful which is also useful.

If you look at old manuscripts and study early drawings of interlaced patterns or depictions of animal forms chasing each other, and the exquisite richness of colour and gold ornamentation of the finely expressed figures, flora and fauna of later periods, the main impression which shines through is the sheer enjoyment and vitality in the execution of the work. This should be your goal too. Apart from considerations of layout, space, harmony of letterforms combined with decoration, and observation of how things move or grow, if that crucial spark of vitality is not present, the result will be dull, no matter how well executed. On the other hand, a few shortcomings in technique may be overlooked if the result is lively and sincere – it will be a delight to look at.

Drawing, painting and calligraphy have been common threads in my life and a passion since an early age. Italic handwriting lessons at school and a subsequent birthday present of a copy book and Mitchell nibs, which I still possess, set me on my road. I was encouraged to use those emerging skills to produce cards and presents for family and friends, and I have never lost the enjoyment of making and giving. Whatever you make will be unique and may be tailored for each recipient or occasion. Whether straightforward in concept and execution, or the product of a major challenge to your skill and ingenuity, individual handmade items are always popular and well received.

# CHAPTER ONE
# Centuries of skills

figure 2
The earliest examples of illuminated manuscripts in the Western world stem from Ireland. The Lindisfarne Gospels – Opening of St Mark. Cotton Ms Nero D iv, folio 95. Lindisfarne, England, c.698AD. 259 folios, 430 x 250mm (17 x 10in). (British Library)

The history of illuminated manuscripts is a long and complex one, so in this brief survey I have simplified it by describing the major periods with their distinctive styles. There was obviously gradual development and evolution within the basic styles mentioned, which can be studied elsewhere *(see Further reading, page 92)*.

## INSULAR (c.600-900 AD)
The earliest flowering of illumination in the Western world occurred in the seventh century AD in Ireland, where the monks of St Columba and other church leaders wrote out and decorated service books for use in their monasteries. They also took these books with them on their travels to spread the Word of God to Britain and into Europe.

The Lindisfarne Gospels *(fig. 2)* and the Book of Kells are the most outstanding examples of this period. Their patterns and motifs have many similarities with the jewellery and metalwork of the time, the most common being spirals of various kinds, steps, frets and intricate interlaced knots. Animals and birds were shown in stylised and symbolic rather than naturalistic forms, chasing or biting each other amongst the dense carpet of pattern. Human forms are not often found but were usually drawn in the same ornamental fashion as animals. The Evangelist portraits and other figurative miniatures in the Book of Kells and the Crucifixion in the Durham Gospels are notable exceptions.

The pigments used were varied and brilliant. Gold was available but was not generally part of the illuminator's repertoire, yellow paint being used instead. However, gold was used occasionally in manuscripts from southern England – the Vespasian Psalter and the Stockholm Codex Aureus, for instance – and elsewhere in Europe.

## ANGLO SAXON (c.900–1066 AD)
Three centuries after the introduction of the spectacular intricacies of the work of Irish monks, the craft of illumination reached new heights in the Anglo Saxon period preceding the Norman Conquest of 1066. Many of the

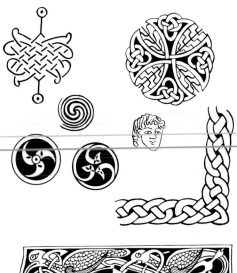

figure 3 Anglo Saxon motifs (c.900-1066)

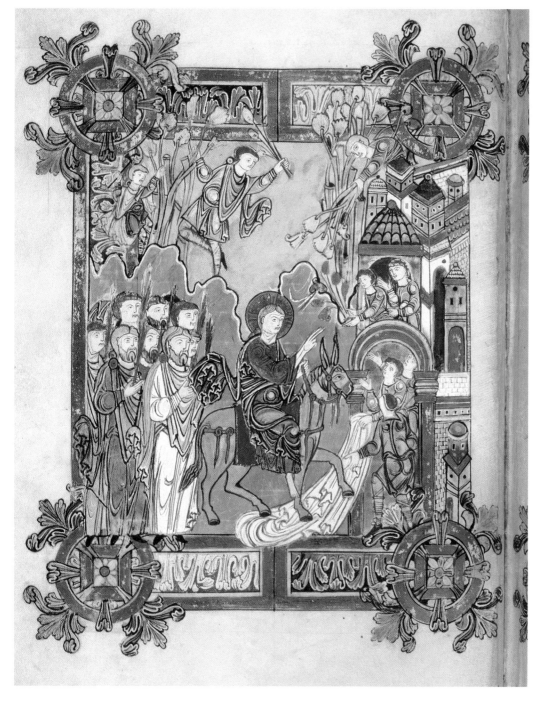

figure 4
Illumination reached new
heights just before the
Norman Conquest of 1066.
The Benedictional of St
Aethelwold – The Flight from
Egypt. Additional MS 49598,
folio 45 v. Winchester, England
c.980AD.
119 folios, 295 x 220mm ($11^{5}/_{8}$ x
$8^{5}/_{8}$ in. (British Library)

figure 6, *opposite*
Mediaeval scribes delighted in depicting scenes from everyday life. The Luttrell Psalter – The Sower. Additional MS 42130, folio 170 v. England c.1335-40. 309 folios, 350 x 245mm (13¾ x 9⅝ in. (British Library)

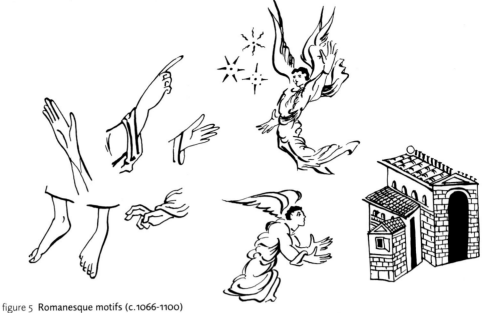

figure 5  Romanesque motifs (c.1066-1100)

finest English manuscripts of this period were produced in Winchester; Canterbury was also an important centre.

The Benedictional of St Aethelwold *(fig. 4)*, which was probably made in Winchester about 980 AD, shows the development of naturalistic drawing, although buildings are not shown in perspective and still seem more stylised than naturalistic. The figures have great dignity, the drapery is bold and decorative and drawn with much skill. The heavy borders to the

even greater importance in the post-Conquest Romanesque period (1066-1100), giving rise to endless variations of decorated capitals. The lettershape might contain the essence of the text in pictorial form, or be made up of human and animal forms with an entwining scroll of no relevance to the text. Such imaginative fantasy appears in the borders of early Gothic manuscripts. The simpler, coloured initials often had plain backgrounds.

figure 7  Early Gothic motifs (c.1100-1350)

miniatures and chapter openings are decorated with scrolling acanthus leaves, and burnished gold is used to great effect alongside bright, clear colours.

In contrast, the Utrecht Psalter style was looser and almost modern in concept. Vigorous, multi-coloured line drawings are presented within the text without confining borders, as in illustrated story books. The Harley Psalter, early eleventh century (Harley MS 603), is a superb example.

Although historiated initials are rooted in Insular art, the initial letters began to assume

## EARLY GOTHIC (C.1100–1350)

As learning spread amongst the wealthy, they commissioned religious books for their own use in private chapels. The scribes were no longer exclusively monks – who continued to supply their own needs – but professional craftsmen who set up workshops in university cities and large towns from about 1200 onwards to cope with the increasing demand.

The biblical scenes in religious books of this period contained depictions from the artist's own times, not from ancient history. Naturalistic figures wear mediaeval clothing

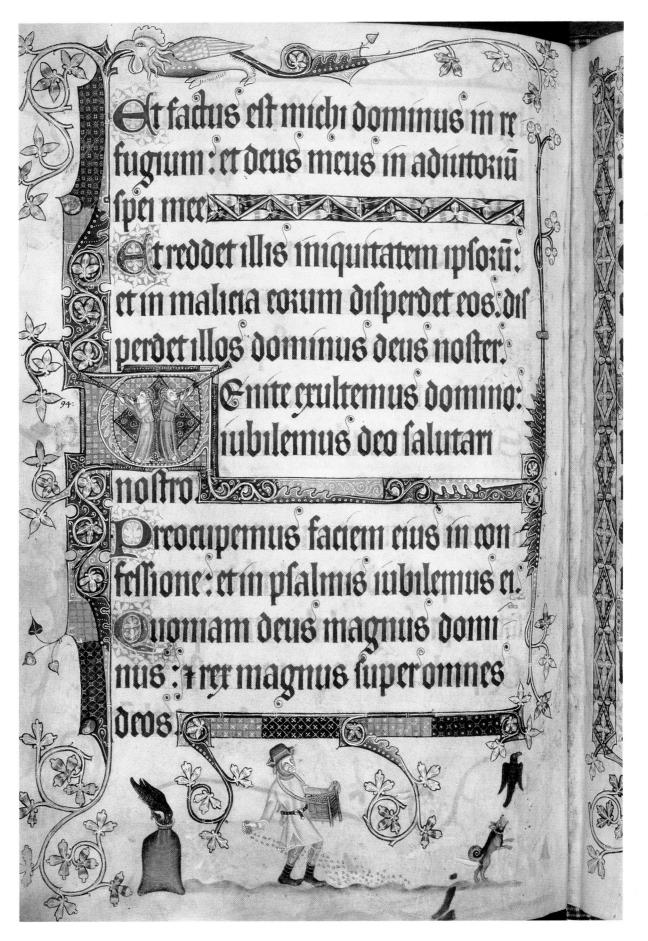

Et factus est michi dominus in refugium: et deus meus in adiutoriū spei mee.

Et reddet illis iniquitatem ipsorū: et in malicia eorum disperdet eos. disperdet illos dominus deus noster.

Enite exultemus domino: iubilemus deo salutari nostro

Preocupemus faciem eius in confessione: et in psalmis iubilemus ei.

Quoniam deus magnus dominus: 7 rex magnus super omnes deos.

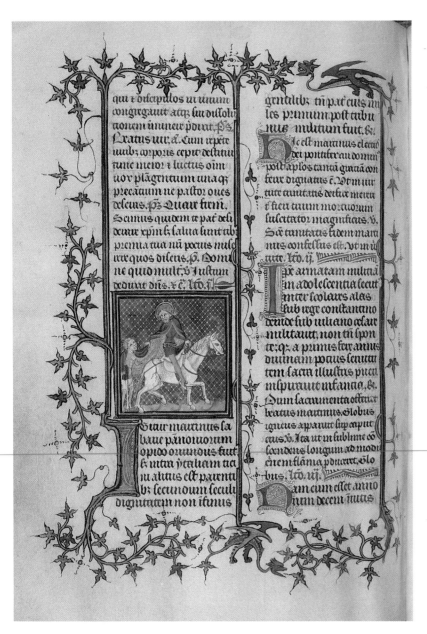

figure 8
Later Mediaeval manuscripts featured coloured initials and ivy leaf borders. French Breviary – St Martin Sharing his Cloak with a Beggar. Latin MS 136, folio 365b. Paris, France, early 15th century. 411 folios, 185 x 133mm (7¼ x 5¼ in). (John Rylands University Library of Manchester)

figure 9  Mediaeval motifs (c.1350-1500)

and the settings are splendid Gothic buildings. The Luttrell Psalter (*fig. 6*) even depicted scenes from everyday life in the Middle Ages, drawn with humour and an eye for detail, although unrelated to the text. The strange, grotesque beasts in the margins added to the idea that decoration was not intended only for enlightenment, but also for the interest and amusement of the reader.

Also at this time, the plain gold backgrounds to initials changed to tiny patterns of diapers, lozenges or checks with alternate blue and red squares, or gold scroll work on flat colour.

Borders were of a filigree line design, embellished with ivy leaves and tiny gold dots. This style was echoed by delicate outline flourishes around the large capitals.

## LATER MEDIAEVAL (c.1350–1500)

One major element of illumination, the miniature, developed from its original place within the historiated initial to become important in its own right. The use of burnished gold or coloured initials, strongly patterned Gothic script and ivy leaf borders (*fig. 8*) continued as before, with the addition of heraldry and narrative roundels which showed the text in pictorial form. Heraldry was an important feature to salute the book's patron, who was often shown as a portrait head or with members of his family, as part of the decoration.

The Bedford Hours (*fig. 10*) is a luxurious example of a privately commissioned devotional book, although subjects other than religion were becoming popular.

## THE RENAISSANCE (c.1400–1600)

In Italy, the problem of combining initial, text and borders was solved in two ways, both inspired by the work of earlier times. One solution was the flattened white-vine scroll pattern (*see fig. 12*), derived from Ottonian manuscripts of the eleventh and twelfth centuries, such as the Trier Gospels (*fig. 11*), combined with a new 'humanist' hand based on the script of earlier manuscripts. The scrolls follow schematic, rather than free, patterns, with parti-coloured grounds of blue, green,

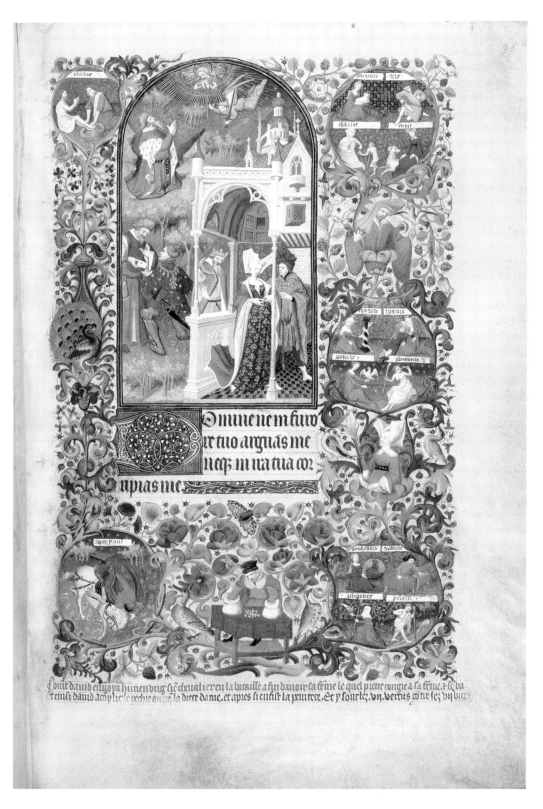

figure 10
Luxurious devotional books were sometimes privately commissioned in the Later Mediaeval period. The Bedford Hours - The Story of David and Bathsheba. Additional MS 18850, folio 96. Paris, France, c.1423.
289 folios, 260 x 180mm (10$^1$/$_4$ x 7in). (British Library)

figure 12 Renaissance motifs (c.1400-1600)

found themselves out of work, although some early printed books did have hand-painted decoration. The craft eventually died out and it was not until the late nineteenth and early twentieth centuries that interest was revived in these ancient skills. Those practising the craft today owe a debt to William Morris, who began its revival with the Arts and Crafts Movement, and Edward Johnston and Graily Hewitt who researched into mediaeval gilding and painting techniques.

Illumination and decoration of manuscript books were not isolated from painting, architecture and other art forms. The artists making the books were reflecting and contributing to the style of the time in which they lived. This is an important point to remember in your own work: try to inject your life and times into the motifs you choose. Build on traditions and ideas of the past, but do not copy them slavishly or your work will not develop. Choose what is most appropriate and adapt it; this is a natural process which artists have followed for centuries.

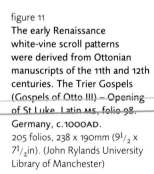

figure 11
The early Renaissance white-vine scroll patterns were derived from Ottonian manuscripts of the 11th and 12th centuries. The Trier Gospels (Gospels of Otto III) – Opening of St Luke. Latin MS, folio 98. Germany, c.1000AD.
205 folios, 238 x 190mm (9$^1$/$_2$ x 7$^1$/$_2$in). (John Rylands University Library of Manchester)

red and yellow, giving a two-dimensional feel.

In contrast, a later style drew its influence from the classical proportions of Imperial Roman architecture and inscriptions. The urns and swags, and even the coloured, serifed capital letters, have a monumental, three-dimensional quality (fig. 13).

By the sixteenth century, miniatures and decorations became more naturalistic, following the quest for accurate perspective and greater realism as seen in large paintings. Borders dominated the page, making complete frames for paintings of biblical scenes or small amounts of text.

After the invention and spread of printing with movable type, the scribe-illuminators

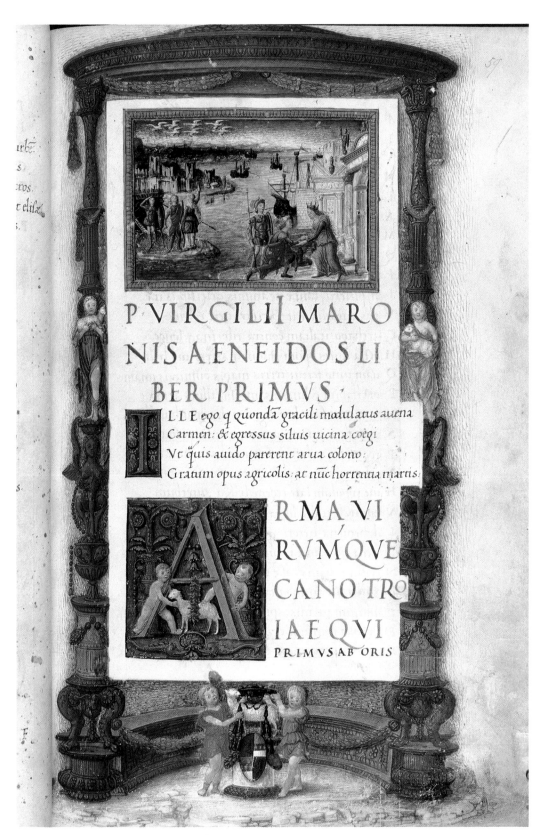

figure 13
The later Renaissance style drew its inspiration from classical Roman architecture and inscriptions. The Works of Virgil - Opening of the Aeneid. King's 24, folio 59. Padua, Italy, c.1499.
245 folios, 283 x 180mm (11 x 7in). (British Library)

# CHAPTER TWO
# Materials

Only very basic materials are needed to begin with: pen, pencils, layout paper, ink, paint and a brush or two, but a drawing board of some kind is essential.

Various types are available. A basic board which can be propped against a table at an angle, or laid flat, according to the task in hand, is suitable for beginners. Such a board is also useful for stretching paper.

Other items are used in the five projects and these can be added to your basic collection.

## CARE OF MATERIALS

- Wash out brushes thoroughly after use, using a little soap to clean out the colour. Store them bristle end up in a jam jar.

- Don't leave brushes soaking with the water rising over the metal.
- Wipe pen nibs and reservoirs after use. Wash and dry them thoroughly, or they will clog with ink and eventually corrode.
- Replace caps and lids on paints and inks to avoid spillage and evaporation. A pad of Blu-Tack or masking tape fixed to the bottom of an ink bottle prevents it from tipping over.
- Push knife and scalpel blades into cork or a piece of eraser when not in use, thus protecting both the blades and your fingers.
- Buy the best equipment you can afford. This pays dividends in results, as well as giving the extra satisfaction which comes from

figure 14
Essential equipment and materials are conveniently acquired if you buy the best you can afford and add to your collection as you progress.

1 Drawing board
2 T square
3 Layout pad
4 Pencils
5 Set square
6 Protractor
7 Scissors
8 Scalpel
9 Plastic eraser
10 Non-waterproof black ink
11 China palette
12 Watercolour paints
13 Gouache paints
14 Masking tape
15 Sable brushes
16 Plastic ruler
17 Pen holders
18 Nibs and reservoirs
19 Glue stick
Extras:
20 Compass
21 Metal ruler
22 Dividers
23 Ruling pen
24 Technical pen
25 Flexible curve
26 Masking fluid
27 Bone folder
28 Adjustable set square
29 Gum sandarac

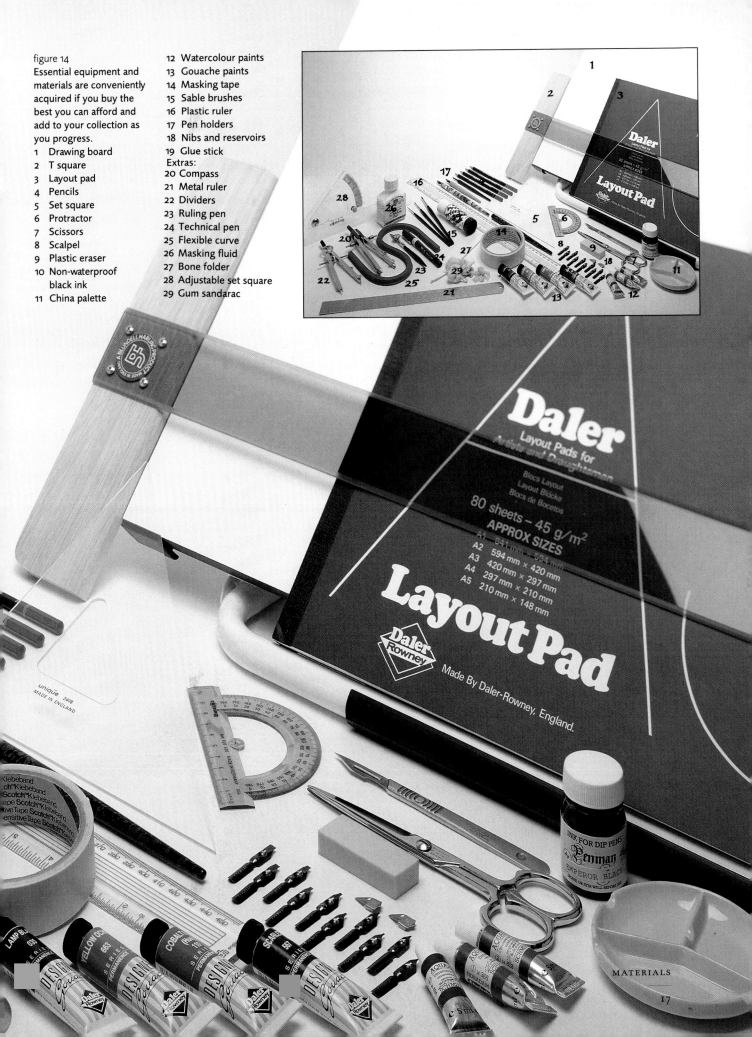

Daler
Layout Pads for Artists and Draughtsmen

Blocs Layout
Layout Blöcke
Bloca de Bocetos

80 sheets – 45 g/m²
APPROX SIZES
A1 841 mm × 594 mm
A2 594 mm × 420 mm
A3 420 mm × 297 mm
A4 297 mm × 210 mm
A5 210 mm × 148 mm

Layout Pad

Daler Rowney

Made By Daler-Rowney, England.

# PAINTS AND INKS

It was not until well into the nineteenth century that it was possible for artists to buy ready-made colours in tubes or pans. Mediaeval scribes had to seek out the necessary pigments or minerals, grind them finely on a glass slab, then mix them with gum arabic and water to the right consistency. You can still make your own paints in this way if you wish, but branded paints are best for consistency of colour.

## Gouache

Gouache is a water-based paint which is available in tubes or jars. Designer's is the best quality. Carefully applied with a brush, it gives broad areas of flat colour with a matt finish. Used in a pen, it produces consistent, opaque lines. The colours come in series, graded by cost of pigments and coded for permanence. Choose the most permanent you can, because work fades eventually, when exposed to light.

This basic selection gives you a good start, from which you can mix a variety of colours. Add other colours to your collection when you can:

| | |
|---|---|
| Ivory Black | Alizarin Crimson |
| Scarlet Lake | (or Madder Carmine) |
| Cobalt Blue | Oxide of Chromium |
| Lemon Yellow | French Ultramarine |
| Zinc White | Yellow Ochre |

## Watercolour

Watercolour is available in pans, cakes or tubes. The pans have fewer additives and last longer; they are my preference. Tubes are convenient for mixing large amounts of background washes, but are wasteful if you need only small quantities. Artist's quality provides the best and most permanent colours.

Always use clean water for mixing, otherwise the translucency of the colour will be lost.

## Other paints

- EGG TEMPERA. A mixture of powder colour and egg yolk, tempera can be used very effectively but is rather messy and fiddly to apply. Gouache in tubes is more reliable, especially for beginners.

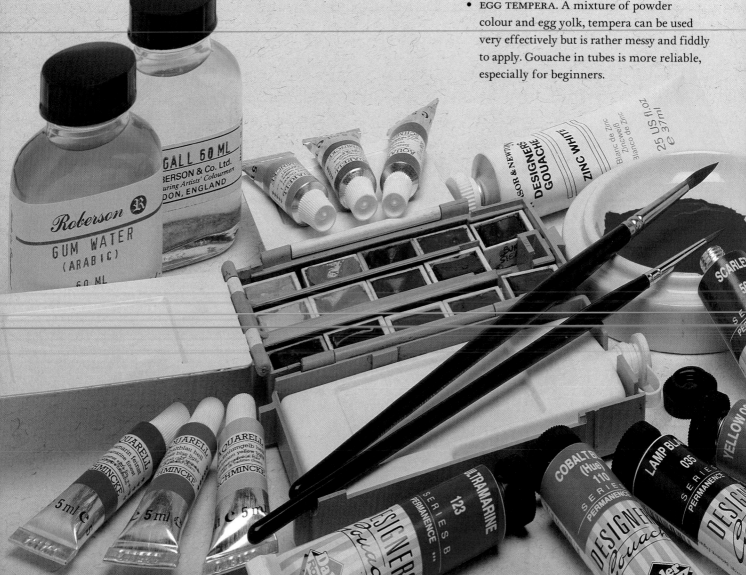

- ACRYLICS The colours are too brilliant for illumination and not as predictable in handling as gouache colours. They are sticky, not sufficiently opaque, do not flow well from a pen and are ruinous to sable brushes.

## Inks

Brands of ink vary in composition and from batch to batch, so find a reliable one which you like. Flow and density are important criteria and the best way to choose ink is through trial and error. Black gouache is a good alternative. Remember that it is not only the ink which affects the quality of the writing – the paper, the type and size of nib and the slope of the writing surface all play their part.

- NON-WATERPROOF BLACK is most suitable for calligraphy and gives a fine, clear line. It can be thinned with distilled water if needed.
- WATERPROOF BLACK clogs the nib. Fine strokes are possible only with difficulty. Wipe the nib often as you work. It is best used when diluted to a light grey for the base drawings for painted decoration.
- COLOURED DRAWING INKS are awkward to use and, because they are dyes, not pigments, are not permanent. Some pigmented inks are worth experimenting with, as they can be mixed with a medium to improve the consistency. Paint is really the best option, as it is more predictable to use. The range of colours is also greater and more subtle.

- FOUNTAIN PEN INK is designed specifically for fountain pens and is generally too thin for dip pens, although some do work well.
- CHINESE STICK INK is ground with distilled water on to a special inkstone. It gives a crisp, black line when well mixed as follows: using an eye dropper or dropper bottle, put two drops of water on to the stone and grind the ink stick, flat end on the stone, in a circular motion for two minutes. The result is a good black ink – and my favourite.

Experiment with the density of the black, noting the formula and results, to find the mix you prefer. Grind it afresh each time, mixing just enough for the work in hand. It can be stored in a jar, but as it has no preservative it will go slimy and mouldy eventually.

## Writing with ink

Before using any ink, always shake the bottle. Load the pen by dipping the nib straight into the bottle or by filling the underside of the nib with a brush. The latter takes longer, but dipping may produce an ink overload. Shake or wipe off any excess, otherwise the result might be a flood instead of a sharp line.

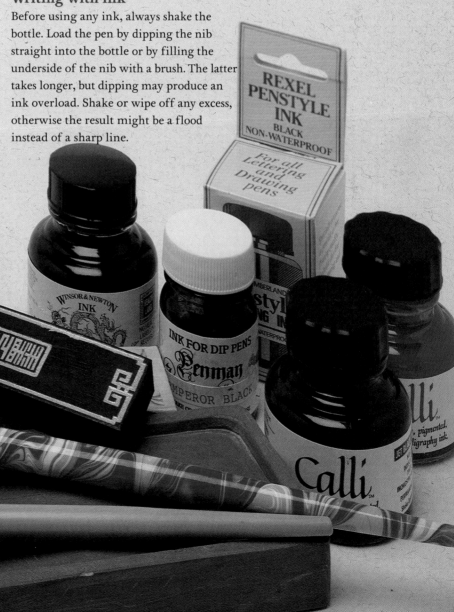

# BRUSHES, PENCILS AND PENS

## Brushes

The finest brushes for watercolour or gouache are made of Russian red sable. The hair comes from the tail of the Siberian weasel (Kolinsky), is springy, absorbent and holds colour well. Sable brushes last a long time, if properly cared for. The shorter-haired ones are best for detailed work but hold less colour than longer-haired types.

Cheaper brushes are available in squirrel, ox, synthetics or a mixture of sable and synthetic. All are adequate but have their drawbacks. Squirrel and ox are soft bristles which wear out quickly and are suitable only for mixing as they do not point reliably. Synthetic hair is not as flexible or sensitive in use as sable and it does not hold as much colour, though the brushes are strong and cheap. The combination of sable and synthetic is a practical compromise for beginners.

Old brushes are useful for mixing colour, loading pens and filling in large background areas. Save your best brushes for your most important work.

## Pencils

Good-quality branded pencils are better than cheap pencils which have gritty leads and can be difficult to sharpen.

Clay and graphite are mixed to form the leads, which are graded according to hardness. The H (hard) pencils range from 9H to H. The high numbers are the hardest and make light grey lines. B (black or soft) leads are graded 6B to B and the higher grades make rich, black lines. HB is the halfway point and is a good all-purpose pencil, but try an F, which is a little blacker than HB and does not smudge as easily.

## Pens

Fountain pens, even those with interchangeable nibs, are not really suitable. The size range necessary for calligraphy is not available, nor are the nibs sharp enough for writing or drawing. The waterproof ink used for drawing is not suitable for use in fountain pens.

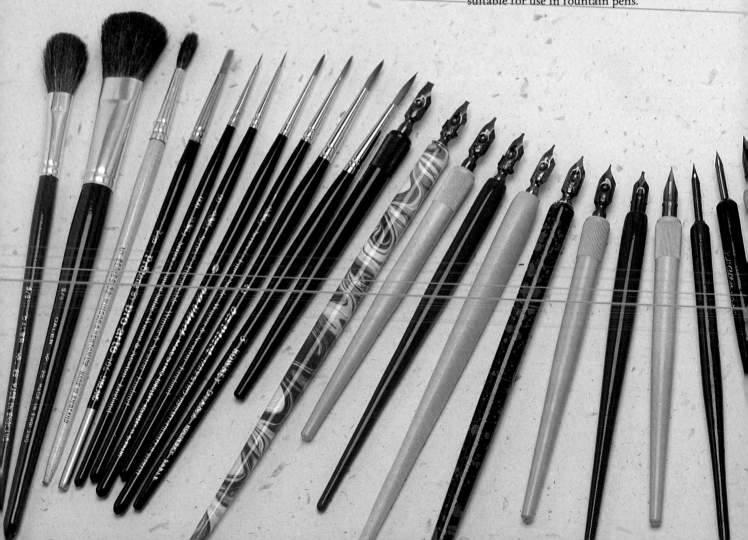

There are several ranges of dip-in nibs for lettering and drawing, available individually or in sets. Most will fit into a standard pen holder. The most widely available lettering nibs are made by Rexel or William Mitchell, and the chisel edges come in straight, right oblique and left oblique (specially for left-handed calligraphers). They are numbered from the smallest, no. 6 (0.6mm), to 0 (3.3mm). Nibs with a separate ink reservoir tend to give a more consistent ink flow than those with one fixed on top of the nib. Experiment to find the type you feel most comfortable with.

Gillott drawing nibs are available in many thicknesses and degrees of flexibility, and your choice will depend on the size and nature of your work. Nos. 1290 and 404 are supple and responsive in use and give a fine or slightly weighted line, depending on the pressure you apply. Mapping pens and crow quills are also suitable for under-drawing, but require a different type of pen-holder.

Pen-holders come in many shapes and sizes, but I find the round-barrelled ones more comfortable to use than the angled ones. They vary in width, so be sure to try before you buy for the first time and choose the one which suits you. I would avoid holders with ink reservoirs attached as the control of ink flow is not as good as with the slip-on type.

All new nibs have a greasy lacquered coating which must be removed before use. Either hold the nib in the flame of a match for a second or two then plunge it into cold water, or simply wash the nib in hot water.

Reeds and quills are by tradition the tools of the craftsman calligrapher and illuminator; some scribes use them today.

# PAPER

The character and quality of your finished work will be affected by the type of paper you choose. The paper should always have a surface suitable for the subject material and the scale of the piece of work.

Small, highly detailed work requires a smooth surface, and the paper needs to have a slight 'tooth' (a fine velvet-like nap) for good crisp writing. If it is shiny or coated with china clay, as some printing papers are, the ink slides on the surface and results in unsightly blobs. The nap holds the ink and gives crisp edges and fine lines. For larger and less intricate work a slightly textured surface is worth trying.

Collect samples of likely papers so that you can test your colours. Some papers need de-greasing with a light dusting of pumice or gum sandarac to improve ink or paint adhesion. Manufacturers, paper suppliers and some specialist shops provide advice as well as samples (*see page 95*).

- HANDMADE PAPER is made in a rectangular mould. There are many surface textures and weights, with four deckle or rough edges. It is expensive, but it is possible to correct mistakes on some types.
- MACHINE-MADE PAPER is made on a roller and is generally less expensive than handmade. The sheets have four cut edges, a consistent surface quality and are available in many colours.
- MOULD-MADE PAPER approximates the look of handmade paper. It is made on a roller, so large widths and lengths are available, and it has two cut and two deckle edges.

## Paper surface

This is determined by the type of fibres used in its manufacture, the type of mesh used in the mould and the method of pressing and drying.

- LAID PAPER has the pattern of vertical and horizontal lines impressed on to the surface. The reverse side is flat.
- WOVE FINISH is achieved by a woven mesh on both the mould and the mat which presses down on to the pulp, yielding an even texture.
- HOT-PRESSED (HP) is a smooth surface achieved by glazing rolls. It is eminently suitable for both calligraphy and illumination.
- NOT SURFACE is lightly pressed to even out the texture, but the pressing does not eliminate the tooth or surface texture entirely. It has more character than HP and you can correct mistakes without ruining the surface.
- ROUGH is allowed to dry naturally and is not pressed. It has an exciting, rugged surface which is most suited to bold work using brush or reed-pen lettering.

## Sizing, weight and grain

- SIZE. Without size (glue) in its composition, all paper would absorb any ink applied to the surface, as blotting paper does. Most handmade paper has size added at the pulp state (internal sizing) but others are surface-sized, usually with gelatine, to repel ink. This can lead to problems with ink or paint beading on the surface, but this is overcome by adding a drop of ox gall or gum arabic to the writing medium. If you need to stretch this paper before working, remember that all the size will be removed if the paper becomes too wet.
- WEIGHT is measured in grams per square metre (gsm) or pounds per ream (500 sheets of any given paper size). Machine-made paper is cut to a wide range of sizes, both metric and imperial measures. Handmade paper sizes are dictated by the mould size. Weight is most important when making manuscript books, because you need to consider the bulk of the folded sheets.

However, if a sheet of paper is too thin, the writing on the other side of the sheet will show through. For framed work, the heavier weights are more stable and less likely to cockle, particularly if watercolour washes are involved.

- GRAIN. If your (machine-made) paper is to be folded (e.g. for a book or a greetings card), you must establish the grain direction of the paper, otherwise the book or card will not open properly or will curl at the edges. The direction can be established by folding or tearing (*fig. 15*). Handmade paper has no grain.

## Your paper stock

Acquire a stock of basic papers, suited to various types of work, as well as some good ones with interesting textures.

- LAYOUT PAPER is generally used for all rough work and sketches. It is thin enough to see through and therefore useful for tracing off various stages and refining your designs; and it is strong.
- CARTRIDGE PAPER for lettering needs to be of good quality to give a balance between tooth and absorbency.
- TRACING PAPER is used for refining design and lettering, and tracing down on to the final paper stock. As it is semi-transparent, it is easier to resolve problems without wasting precious good-quality paper.
- CRYSTAL PARCHMENT (glassine) is useful for protecting work in progress or as an overlay for the finished item. It is also used in gilding (*see page 70*).

Do not feel restricted to using off-white paper all the time. There are ranges of paper available in a wonderful variety of colours, both strong and subtle, with which you can achieve exciting results. Be prepared to experiment.

## Looking after paper

Paper should be kept flat or loosely rolled, away from damp conditions and extremes of heat and cold. Ensure your hands are clean before handling paper and hold it in a loose curve. Lighter-weight papers are easily damaged. They can acquire little creases and dents which are difficult to remove, even by burnishing on the wrong side.

## Vellum

Parchment was the traditional surface for writing before paper became widely and cheaply available. The term 'parchment' covered any type of skin prepared for writing by soaking in lime, scraping and drying under tension. Today it is used for split sheep skin; all other skins are known as vellum, which originally referred only to calf skin.

In mediaeval times, skins were cheap to produce because animals were plentiful. This is not so today, and few manufacturers now specialise in the production of vellum. Labour costs make the finished article expensive. However, after some further preparation by the scribe, a fine vellum surface gives a crispness and density to writing and illumination that is difficult to achieve on any paper.

figure 15
To determine paper grain: without creasing the paper, fold it over loosely in one direction, then repeat the process in the opposite direction. Whichever gives the least resistance is the direction of the grain. Always tear paper with the grain.

# Writing, drawing and painting

### Lettering as a basis for decoration

Beautiful illumination and decoration require a solid basis of the best quality writing you can achieve. The writing and the illumination should work together harmoniously, complementing each other in colour, balance and design. Good lettering can be spoilt by poor illumination, and vice versa.

Studying old manuscripts is helpful but do not use them as examplars for copying. They may contain abbreviations which are difficult to understand, as well as variable letter quality, often influenced by the scribe's idiosyncracies. Old manuscripts are a rich source of information about the way early scribes used readability, beauty and character of writing combined with decoration and arrangement on the page to make a pleasing whole.

Avoid mannerisms in your work by following the formula Edward Johnston devised to help his students understand the principles of good lettering. Each script has its own characteristics which can be analysed by looking at the *weight* of the letters and the *angle* of the pen when writing, thus dictating the *form* of the letters. Order, direction and speed of strokes are other contributory factors.

### If you are a beginner

The examples on pages 26–37 form a rough guide to choosing suitable lettering for your project. Careful observation and practice eradicate common problems which crop up if you work alone; some are illustrated for each script. If in doubt, err on the side of simplicity and avoid over-elaboration.

Other books go into greater detail on letter analysis *(see Further reading, page 92)* but, better still, attend a calligraphy class, if possible, to direct your efforts in a more concentrated way.

### Start with capitals

Capitals (upper case) are easier to cope with than lower case letters, but be sure to progress to the minuscule letters as soon as your confidence allows.

### Write words not alphabets

Once you have learned the basic shapes and can write them rhythmically, write words and sentences rather than alphabets. This method will accustom you to the appearance of the script in blocks.

### Spacing

Letter, word and line spacing are crucial to the success of your work. If this is lacking, legibility will suffer, along with the reader's interest.

WORD SPACING approximately one small o.

LETTER SPACING two straight letters should be the farthest apart; between a vertical and a curve, slightly less; between two curves, still less.

This is governed by the visible space within the letter, which has to be compensated for. Aim for the appearance of even spacing.

LINE SPACING varies from script to script *(see pages 26–37)*. To help you visualise the principles of good letter spacing, a sentence has been written out in each script. Compare and contrast the different pattern and character of each, which you should keep in mind when writing.

### Experiments

Write at different speeds and discover the effects. Change the nib size and/or the body height of the letters and observe what difference this makes.

## Materials

DRAWING BOARD
Padded with several sheets of cartridge or blotting paper tacked down with masking tape. This gives a responsive surface.

| | |
|---|---|
| LAYOUT PAPER | MASKING TAPE |
| SHARP PENCIL | T SQUARE OR RULER |

## General method

1 Fix a sheet of layout paper to your padded board (placed flat) with masking tape.
2 Work out body (x) height by marking off the number of nib-widths for your chosen script on a scrap of paper.
3 Mark off base line, x height and line space on to the straight edge of a long piece of paper (*see fig. 16*). Use this as a ruler to transfer the measurements accurately on to your layout paper or, alternatively, use dividers.

If you have only a ruler, mark both short edges of the layout paper, starting from the same point, before you rule across close to the ruler's edge with a sharp pencil; otherwise the line width will vary.

figure 16 **Ruling up.**

You can use a ready-ruled sheet of lines under your paper, or make your own by ruling up with a fine-tipped black felt pen.

## Before you start work

1 Set up your board in a good light. If your board does not have an adjustable stand, prop it against a table edge or a sturdy object on the table's surface.
2 Sit straight, with both feet on the floor, and don't lean too far forward because this will strain your back.
3 Don't keep the layout paper stuck down when writing. It is easier to move paper than your hand. Keep a guard sheet over the work to protect it from the grease on your writing hand.
4 Write with the tip of the nib and angle the pen steeply to avoid using the underside, as this will result in blotches.
5 Try not to grip the holder tightly, and write with an even pressure on both sides of the nib. It helps to hold a bone folder or short ruler in your other hand as it will take the excessive pressure away from your writing hand and keep the paper in place without smudging or finger marks.
6 Try the pen on spare paper first to get the ink flowing. Rinse and wipe the nib from time to time to stop the ink from drying up.

The following twelve pages give guidelines to forming suitable lettering for your work.

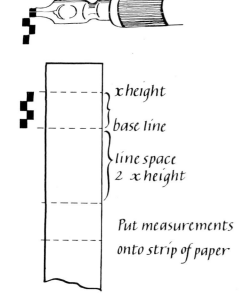

*Transfer marks & rule across or use dividers to step off measurements on to paper*

# ROMAN CAPITALS

ABCDEFGHI
JKLMNOPQ
RSTUVWXYZ

Written with a broad-edged pen, Roman capitals are suitable for use with the Foundational hand on the preceding pages.

Try writing these letters in 'monoline' or skeleton form first, with a pencil. This will help you to understand the essential structure of the letters.

The analysis shown here indicates the basic proportions and similarities of form.

Nib size: Wm. Mitchell 1½

A: steepened pen angle

B: flattened pen angle

C: 0° pen angle

## ∞ MAIN POINTS ℞

**Weight:** 7 nib widths

**Angle:** 30° (some modification required)

**Form:** Round, based on O

**Slope:** None

**Basic proportions:**

1. Circular O

2. Rectangle (¾ width of square containing circle. Same area as circle.

3. ½ width square for narrow letters. Curves still based on circles.

## ❧ RELATED FORMS ❧

**Round**

O C D G Q are all based on the circle. Straight sides relate to the rectangle

**Rectangular**

A H N T U V X Y Z Letters with straight sides and diagonals. All fall within the 3/4 rectangle

**Narrow letters**

**Extra wide**

M = M is the width of the square

W = two Vs side by side (2 rectangles)

E F L B P    S J
R K 1 Curved shapes relate to circles

C D B P R relate to curve of O        A E F H Cross bar at mid point (except A, slightly below)

N W Diagonals join near to stem end    M Joins should be at same height

## ❧ THINGS TO AVOID ❧

B✗ uneven bowls        N✗ Curving diagonals        S✗ Exaggerated central curve

M✗ Legs splay too much    R✗ Exaggerated serifs    P✗ Clumsy joins of bowls

1 2 3 4 5 6 7 8 9 0 & Numerals are the same height

## ❧ SPACING ❧

Should look even, the space between & inside letters visually equal. Two vertical letters should be furthest apart; a curve and a vertical a little closer; two curved letters closer still. Word space = less than O. Line space = approx. height of capitals.

# THE QUICK BROWN FOX JUMPS OVER THE LAZY DOG

# Foundational

g abcdefghijkl ⁞

mnopqrstu

vwxyz  30°

1234567890 & 0

T his Roman minuscule hand is based on a circular 'o', which relates it to the capitals on the next page. 'Foundational' was developed by Edward Johnston for his students, based on the lettering of the Ramsey Psalter (circa 975 AD) in the British Library.

Allow a line space of three times the letter's x height to avoid a clash of ascenders and descenders.

## ℬ MAIN POINTS ℬ

**Weight:** 4 nib widths (x height)
6½ (ascenders and descenders)

**Angle:** mainly 30°

**Form:** Round

**Slope:** None

**Nib size:** Wm. Mitchell 1½

A = steepened pen angle
B = flattened pen angle
C = 0° pen angle

## RELATED FORMS

There are two main groups of letters related to each other. Practice these first to get the 'feel' of the hand.

### Round letters

o c d q b p   These relate to o, but are slightly narrower

### Arched letters

a h m n r    l t u

These are based on o, the second stroke begins inside the first, to make a strong shape. The flat curves of the arches aid the reader's eye to follow the line of writing easily.

c d f s p q

e a   Make sure bowls of e & a are similar in size for a good balance

### Alternatives   a g x y y

### Modified joins

You will find some letter combinations cause problems with spacing. These can be solved by adjusting the letter shapes slightly.

ea fl ff la ri ry tt

## THINGS TO AVOID

n   Too steep a pen angle weakens the arches

n   Arches which are too square

s   Letters too narrow, gives pointed counter spaces

g   Lower bowl of g, if too large, unbalances the letter

m   Uncontrolled arches and bent stems

l   Exaggerated serifs

ff tt   Cross bars too low, or too high

e   Letters made too wide. They appear to tilt backwards.

## SPACING

# The quick brown fox jumps over the lazy dog

# UNCIALS

These pen-written letters actually pre-date what we know as lower case or small letters. There are no capitals as such, just larger uncials. It was much used in manuscripts between the 5th and 8th centuries AD.

Uncials make a strong, ribbon-like pattern and it is this quality which makes it very suitable for writing large blocks of text.

This uncial hand is derived from that of the Stonyhurst Gospels (circa 700 AD). It is simple and directly written, unlike other, later styles which require much pen-manipulation.

## ❧ MAIN POINTS ❧

**Weight :** 3 to 5 nib widths (the example here is 4)

**Angle :** 15°

**Form :** Round. O is _wider_ than a circle

**Slope :** None

**Line space :** 1½ times letter height

**Nib size :** Wm. Mitchell 1½

A = steepened pen angle

B = flattened pen angle

## ❧ RELATED FORMS ❧

Letters fall into three general groups

### Round

o c d e c q p

### Arched

h m u     BR

Round and arched letters are closely related. B and R are similar.

### Diagonal

v w x y     These are where the pen angle must be steepened to achieve the right contrast of weight (thick / thin)

S P F     The curves of s need to be flattened to avoid heaviness. This is also necessary with the lower curve of p and top of f

## ❧ THINGS TO AVOID ❧

u c ✗     Weight in wrong part of the curve

m ✗     Unbalanced inside shapes

N ✗     Diagonal too low

F ✗     Cross bar too low

k ✗     Diagonals poking through stem - should just touch

BR ✗     Central dividing stroke should not touch stem

## ❧ SPACING ❧

Over-generous spacing and the letters no longer relate to each other. Letters too close together and the 'pattern' is lumpy and uneven.

Aim for an even visual distribution of space between and within the letters

ATHLETIC

ATHLETIC

ATHLETIC

the quick BROWN

fox jumps over

the Lazy dog

# VERSALS

A B C D E F G H I J
K L M N O P Q R
S T U V W X Y Z

As the name might suggest, these capitals were originally used as initial letters of chapters or verses. They are made up of a number of strokes, using either a pen or pointed brush.

Versatile and elegant, these letters work equally well as headings or blocks of text. They will give a very effective contrast to most scripts written with broad-edged nibs, especially if colour is used.

Based on Roman capital proportions, there are many other versions and variants to be found.

Nib size: Wm. Mitchell no. 4

## MAIN POINTS

**Weight:** 8 times width of stem (3 : 24 nib widths)

**Angle:** Turn pen for broadest strokes on stems. Thinnest for serifs

**Form:** Round. O is circular

**Slope:** None

**Construction:** Stems made with 3 strokes, outer ones curve inwards, the third fills the gap. Serifs added last.

Round letters: draw inner shape first. Use shallow pen angle to avoid weak joins

Letter proportions were often altered in manuscripts, to make more words fit onto the line.

Round letters

# OCDGQ   PRB

All related to O                                     are related by their top curves

Width of curved strokes need adjusting — make slightly wider than the uprights, so that they <u>look</u> equal.

Straight stem letters                          Diagonal letters

# IEFHJLT   AVWNM

**Variations:** Experiment with different nib widths at the same cap. height to see how the letters appear stronger or finer, by altering height to width ratio. Without serifs, they can look quite modern.

# AB   AB   AB

Heavier        Lighter        Without serif

O ✗   Points or bad joins at base of O

S ✗   unbalanced S. Inner shapes pointed not rounded.

D ✗   Uneven thickness of straight & curved strokes

M ✗   Legs of M too splayed

# THE QUICK BROWN FOX JUMPS OVER THE LAZY DOG

TECHNIQUES — WRITING, DRAWING AND PAINTING

# Gothic

ABCDEFGHI
JKLMNOPQR
STUVWXYZ

abcdefghijklmn
opqrstuvwxyz

Widely used throughout Europe in the Middle Ages, Gothic makes a dense pattern, hence its popular name of 'Blackletter'. It is not the most legible of hands, but useful for small decorative pieces.

There are several variations of the Gothic hand; this one has been adapted for writing with a metal nib from the Textura style.

## ❧ MAIN POINTS ❧

| | |
|---|---|
| Weight: | 5 nib widths (x height) |
| | 7 capitals |
| | 6½ (ascenders & descenders) |
| Angle: | approx 40° |
| Form: | Angular    Slope: None |
| Line space: | 1 times x height |
| Nib used: | Wm. Mitchell 1½ |

## RELATED FORMS

Most important is the regularity of the counter spaces contained by the strong vertical strokes. Letters are grouped according to how the arches are made:

1. Flattened top arch taken from previous stroke

o c d g

2. From stem, thin stroke angles steeply upward

n m p a e h b

Make straight strokes in one go, pausing to change direction for 'feet', but keeping pen angle consistent at 40°
Turns are made approx 1 nib width from top or bottom

h d u

The first 'foot' is always short, the second slightly more pronounced.

### CAPITAL LETTERS

Vertical strokes in the round letters are made to help establish the letter width.
If the second curve is made as stroke 2, the letter can end up too wide. The hair lines fill what would otherwise be 'holes' in the visual pattern.

## THINGS TO AVOID

Making letters too wide  × a

Ascenders made too tall  × b

Unevenness of counterspaces  m ×

## SPACING

Space inside the letters should look equal to the spaces between the letters

jumps

### SHARED STEMS

It is possible to combine two letters by using a shared stem which emphasises the compactness of this hand.
Mediaeval scribes would also abbreviate or break words to keep the right hand edge well-defined.

w œ
p pa

The quick brown fox jumps over the lazy dg

# Italics

abcdefghijklmn

opqrstuvwxyz

ABCDEFGHIJ

KLMNOPQ

RSTUVWXYZ

The italic hand was developed during the Renaissance in Italy, mainly for letter writing. It can be written quickly, is elegant and easily legible. The steeper pen angle, slight slope & arches which spring from the stem give it a wonderful flowing quality. Try to retain this flow as you practise.

| MAIN POINTS | |
|---|---|
| Weight: | 5 nibwidths (x height) |
| | 7 (capitals) |
| | 9 (ascenders & descenders) |
| Angle: | 45° |
| Form: | Oval, based on a, not o. |
| Slope: | about 5° |

A = steeper angle  B = flatter angle

Nib size: Wm. Mitchell 1½

## ⅔ RELATED FORMS ⅗

The key letter is made in 3 strokes. 1 is pushed on the return; 2 is flattened; 3 is parallel to 1. Most of the lower case letters follow this form, making two groups, depending on whether the first stroke is

A: Anti clockwise: a d g q    b p are similar, but start as group B

B: Clockwise: n h m r    u y begin anti clockwise as group A

Oval letters  o c e s   all occupy the same space    All upstrokes are pushed

n p a d   Arches break from mid point of stem. Triangular spaces at tops of letters relate to those at the base (these slightly larger).

l b h   Even curved letters have a 'parallel' quality

t f s   Cross bars hang from the x height line
Top curve of s relates to that of f.

## ⅔ THINGS TO AVOID ⅗

p  Making letters too round or starting strokes too high up

d  Too steep a pen angle gives unbalanced letters

f t  Making letters too tall. Cross bars end up in the wrong place.

m a  making letters which do not relate. eg. uneven spaces in m and a too round.

## ⅔ SPACING ⅗

Generous interlinear space is needed because of height of ascenders & descenders.

jumps   Begin by using generous letter spacing too; you'll see the shapes more clearly, then start to close the space up. Inside and outside spaces of the letters should always look even.

# The quick brown fox
# jumps over the lazy dog

## Nib sharpening

To make good, crisp letters the nib must be sharp. The tip can be honed gently on an Arkansas stone or a piece of fine wet and dry paper (400 grade). There is no need for a lot of pressure, but the pressure must be exerted evenly. Follow these easy steps *(fig. 17)*:

1 Place the sharpening stone or w/d (wet and dry) paper on a flat surface, and add a drop or two of water.

figure 17

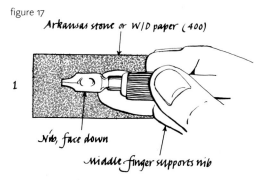

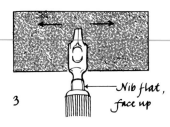

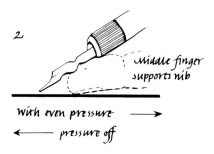

2 Place the nib, upperside down, on to the dampened surface, supported by your middle finger. Pull the nib to the right, pushing down gently and evenly.

3 Lift the nib slightly and move it back to the left, still in contact with the paper. Repeat two or three times. Left-handers should reverse the directions, i.e. pull to the left, move back to the right.

4 Put the underside of the nib flat on to the paper and move to the left and right once, to remove any burrs of metal. Touch the nib's corners on the paper for the same reason.

5 Check with a magnifying lens that the sharpening is even on both tines of the nib.

6 Try out the sharpened nib with ink on layout paper.

Take care not to over-sharpen, otherwise you will cut into the paper with the nib corners. Step 4 helps to avoid this.

## Drawing and painting

Train your own visual awareness of the things around you, so that you learn to 'see' them, not just look at them. Many people say they cannot draw, but what they really mean is they do not 'see' or understand the object they are trying to put onto paper.

Here are two exercises to help overcome this. As with all skills, good drawing takes practice.

1 Turn a photograph or drawing of a simple image upside down and, starting from the (new) top, copy it. Your mind cannot accept the upside down image as logical, so you must concentrate on relating one line to another. You will be surprised how accurate the result will be.

2 Look at the space *around* an object, a dining chair for example. Draw the spaces, starting where one edge touches another, i.e. where the back or the legs join the seat. Concentrate hard on these shapes, not on the object itself. By doing this you draw the object without realising you are doing so.

In both these exercises, pay attention to angles, line lengths and so on. Because you are looking in a different way and are not telling yourself what the object *should* look like, drawing becomes a sort of unconscious activity. These exercises usually produce the confidence to draw objects the right way up! For greater

detail on this subject, the book *Drawing on the Right Side of the Brain (see Further reading, page 92)* is invaluable if you want to learn how to draw, or improve your drawing.

Keep a sketch book for practice. You will find it a valuable resource for the future, as well as a record of your improvement. Make sketches and notes of flowers, trees, animals – observe how they grow and move. Study buildings or anything which interests you. Or, if you have little confidence in your drawing ability, cut out appropriate pictures from magazines or use books as references. Draw these at home, using the methods already outlined, thereby learning out of the public eye!

## Materials

Soft pencils are suitable for drawing on most paper as hard ones can dig in too much, although a 6 or 9H is useful for ruling up lines to write on. The faint lines or indentations should hardly be noticeable, so there is no need to rub out and risk damaging your work.

Start drawing with an HB. The marks can be erased easily if your touch with the pencil is light. Plan your drawings on thin layout or tracing paper. You can then place another sheet over the original and make modifications without destroying it.

Always keep your pencils sharp. Use a scalpel to achieve a needle-sharp point without shattering the lead, which can happen with a pencil sharpener. The pencil point can be kept honed between sharpenings on an emery block.

## Transferring work

Here is a good method for transferring a working drawing to the finished piece:

1 Using a soft pencil (2-6B), rub the lead gently over the back of the drawing (either over each line or as a block) to give a good coating. Rub off any surplus with your finger or a piece of crumpled paper.

2 Test on a piece of scrap paper and ensure there is enough graphite to make a clear mark.

3 Put the drawing, right side up, on your good paper. Use a harder pencil and trace carefully over the whole drawing (not pressing too hard or the lines will be indented), thus transferring the image on to your finished piece.

4 The drawing may be faint, so strengthen the lines with a light touch of an HB, or go over it all with a dilute waterproof black ink prior to painting.

## Consider colour

You do not have to use black ink on white paper for every piece of work. Experiment with coloured paper as well as coloured lettering to suit the mood of the work, or the occasion for which it is intended. Decide whether it needs a subtle treatment or the opposite; a delicate touch and subtle illustrations may be more suitable than strong, bold ideas. This is dealt with further on page 62.

Study the work of professional calligraphers, illuminators and painters, including the pieces at the end of this book *(see Gallery, pages 81-91)*, particularly their use of colour and form to convey mood. Choice of colour is a personal decision and can be strongly influenced by one's surroundings. For instance, the heavy, dark tones of the early paintings of Dutch peasants by Van Gogh were vastly different from his later works, which reflected the bright colours and sunlight of Provence.

## Colour principles

EXPERIMENT by writing a few words or painting blocks of colour in red, blue, green and yellow on scraps of coloured and white paper, and then compare them *(fig. 18)*.

A TOUCH OF DRAMA or contrast can be added with gold or a strong primary colour, such as red.

KEEP COLOUR SCHEMES SIMPLE because too many contrasting colours compete for attention and distract the eye.

CREATE A HARMONIOUS EFFECT by using a close tonal range of colours *(fig. 18)*.

## Mixing colours

There is a wide range of gouache and water-colour in ready-mixed tube colours. You can mix many of these yourself from a carefully chosen basic range of colours *(see page 18)* with the addition of Cerulean Blue.

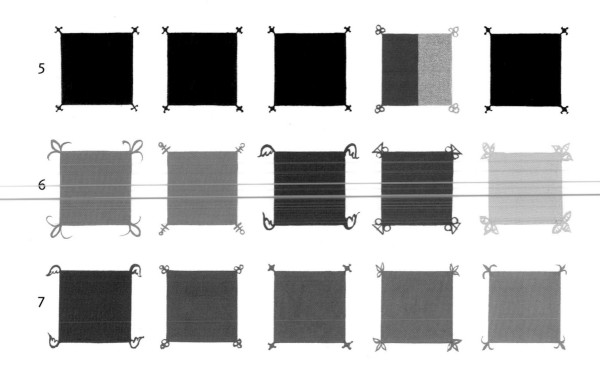

figure 18
1 Cold colours recede.
2 Warm colours come forward.
3 Light on dark dominates, light on light recedes.
4 Dark on light dominates, dark on dark recedes.
5 Contrast added with gold or red.
6 Too many contrasting colours compete for attention.
7 Close tonal range creates a harmonious effect.

ILLUMINATION AND DECORATION FOR CALLIGRAPHY

PRIMARY COLOURS of red, yellow and blue are, by tradition, base colours which cannot be made by mixing.

SECONDARY COLOURS are made by mixing two primaries together, for example:

    *red   +   yellow   =   orange*

TERTIARY COLOURS are those made by mixing three or more colours together.

   If you mix the three primaries, the result is a neutral grey. Useful greys may also be mixed from blues and browns:

*Cobalt Blue    + Venetian Red   = warm grey*
*Cerulean Blue   + Venetian Red   = cool grey*

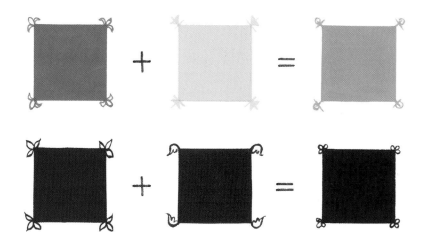

figure 19 Mixing, using colour bias.

figure 20
Tonal colour wheel. Two each of the primary colours (written in capitals) are used to show warm and cool bias; mixed in equal amounts, a range of dull and bright secondaries are made (outer layer). Mid and light tones are created by mixing with an equal amount of Zinc White (inner layers). Complementary colours are placed opposite each other.

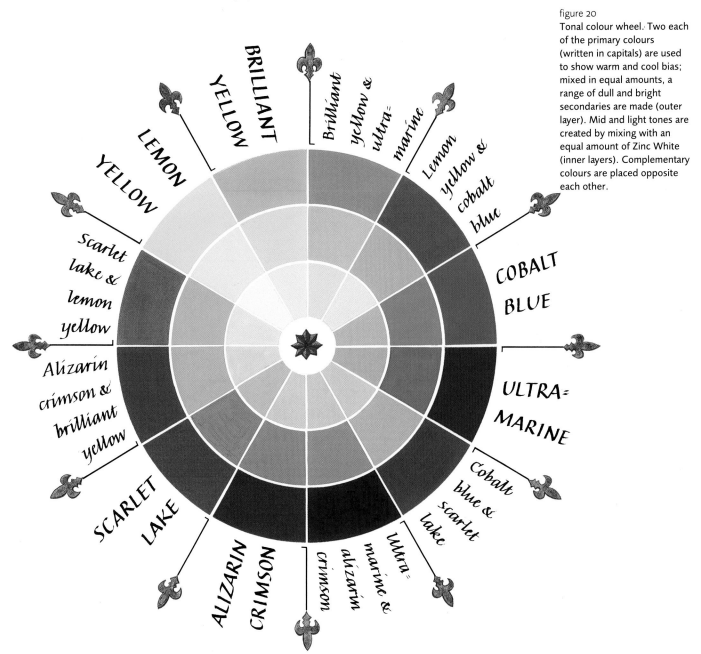

For mixes to be effective, and to avoid grey or muddy results, primary colours must be chosen according to their bias *(fig. 19)*:

Ultramarine - *purplish blue*
Cerulean Blue - *greenish blue*
Alizarin Crimson - *purplish red*
Scarlet Lake - *yellowish red*
Lemon or Aureolin - *greenish yellow*
Gamboge or - *reddish yellow*
Cadmium Yellow Deep

To mix a bright green, choose a blue and a yellow biased towards green:

*Cerulean Blue + Lemon or Aureolin*

To mix a rich purple, choose a red and a blue with a bias to purple:

*Ultramarine + Alizarin Crimson*

Always use clean water for mixing and keep a jar of water handy for rinsing brushes between mixes.

to give body to the colour. On white paper, thin the colour with water. Colour brilliance can be lost by adding white, and warm colours are cooled by it. Add a touch of warm colour to avoid coolness in tints of blue.

## Making shades

There are two methods.

Add the complementary to your colour – it will not upset the harmony or dirty the mix.

*red + green = brown*
*blue + orange = grey (Cerulean gives a greenish grey)*

Add black gradually to the colour *(fig. 22)*. Lamp Black gives cool greys, Ivory Black gives neutral to warm greys.

## Mixing paint (gouache)

Squeeze a small blob of colour on to a clean saucer or palette – use a white one to avoid colour distortion. Add a few drops of clean water with a brush or eye-dropper. Mix until

figure 21
Making tints.

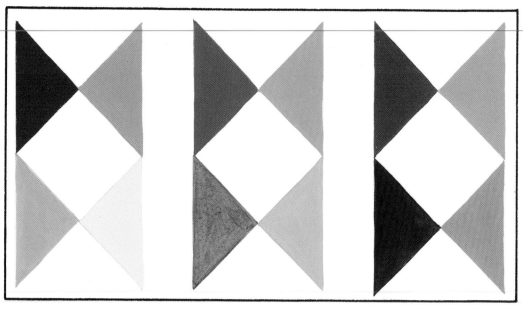

## Making tints

Use Zinc White for the cleanest and lightfast tints of gouache *(fig. 21)*. Gouache can be thinned with water for lighter tints, but it is safer to use white because gouache lacks the bright translucency of watercolour. White also gives a continuity to the overall effect of opaque colour.

For watercolour, use artist's Chinese White. You should use this only on coloured paper

the paint reaches the consistency of single cream. Keep a different brush for each colour and change the water often; this will prevent muddiness in the mixed colours.

Mixing tube colours the day before you use them allows excess glycerine to evaporate, but keep the colour moist by covering the palette with cling film. Mix up enough of each colour for the job in hand and make a note of each colour mix with the proportions used, so that

figure 22
Making shades.

you can repeat it when necessary. The same process applies to mixing watercolours from a tube, except that the amount of water used affects the tone, rather than the consistency.

## Laying areas of flat colour

It takes practice to achieve a flat, even layer of colour. Using a brush appropriate to the size of the work (a no. 1 or a 2 are good all-purpose sizes), take up a reasonable amount of paint and work steadily to fill in the open spaces with even strokes. Forget the edges for the moment, aim to keep the paint moving and wet! Then take a smaller brush (no. 0 or 00) and work carefully up to the edges.

Try to work quickly so that the layer of paint is put down in one go. Ridges or patchiness may appear if it dries before you have finished. With the right consistency, the paint should dry beautifully flat without streaks.

## Writing with paint

When writing with paint in a pen, the flow of paint is helped by adjusting the angle of your drawing board: it should be shallow, even flat, so that the colour doesn't run to the bottom of the letters.

Load the nib with a brush, stirring the colour often to stop it separating; clean the nib frequently or the paint will dry and clog the flow.

You may need to add more water to the paint to counteract evaporation, especially in a warm room, but avoid over-dilution or the colour will alter. Sometimes it is easier to write without a reservoir on the nib; experiment before tackling the finished piece.

If paint flow is still a problem, add a few drops of ox gall or gum arabic to the paint. If the paint is inclined to be sticky, put the gum arabic into your water jar. Ox gall improves paint adhesion as well as flow; gum arabic has the same properties, and adds an extra gloss to the colour.

# PROJECT I
# BORDERS AND A BOOKMARK

Borders can be as simple or as elaborate as you care to make them and they can be worked successfully into many designs *(see fig. 36 on page 48)*. Simple or complicated, the procedure is basically the same.

## SIMPLE BORDERS

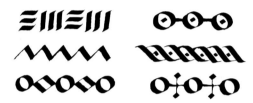

figure 23 **Simple pen-drawn patterns.**

At their most basic, borders can be simple pen-made patterns *(fig. 23)*. Experiment with black ink, colour or a combination of both, and use different pen widths to vary the possibilities further.

When combining borders with calligraphy, let the borders complement the text, not dominate it. Try to find a pattern which suits the work.

The examples in figure 24 are loosely based on historical models, and are in module form (indicated by dotted lines), which can

Mitre     Zig zag

Square

figure 25

be repeated as needed, paying due attention to the corners. Drawing corners requires some ingenuity and common sense. Some patterns, particularly squares *(fig. 25)*, work out easily, but others need a plan to suit the repeat.

figure 24

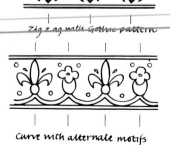

strand interlace with 'end'

Zig z ag with Gothic pattern

Curve with alternate motifs

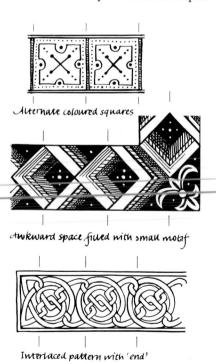

Alternate coloured squares

Awkward space filled with small motif

Interlaced pattern with 'end'

Work through the problems on layout or tracing paper until you have a satisfactory solution. One way is to leave the corners blank and then devise an appropriate knot or motif (*fig. 26*) to fill in the space. There is plenty of inspiration in historical manuscripts.

Knot          Diamond

figure 26

## CELTIC INTERLACE BOOKMARK
### Materials
Basic equipment (*see page 17*)
Layout and tracing paper for roughs
Waterproof black ink and fine nib (Gillott 850)
Pencils: HB (drawing), 4B or 6B (carbon), 6H (tracing down)
Brushes: sable nos. 0 and 00 for painting; squirrel mixing brush
Gouache: Ultramarine, Cobalt Blue, Yellow Ochre, Cadmium Yellow Pale, Permanent White
Technical pen 0.25mm (optional)
Matt or gloss spray (optional)
Coloured pencils for roughs
Metal ruler
Scalpel and 10A blade
Plastic eraser
Masking tape
Scrap card for cutting on
Medium-weight smooth-surfaced card or heavy cartridge paper

## Work plan
1  Draw out the size of the bookmark on tracing paper.
2  Using figure 28 and the measurements in the caption, calculate how many modules of the interlaced pattern in figure 31 fit into the shape. If you are using a different pattern, you may need to adjust the dimensions. With a sharp HB pencil or fine pen and ink, make an accurate tracing of the complete design on your tracing paper (*fig. 31*). Draw out the shape on to the card ready for the finished piece.
3  Choose your colours, or follow those given, and work the design on a separate piece of layout paper, placing the sheet over the master drawing and colouring the pattern in roughly (*fig. 30 overleaf*). Use coloured pencils for speed, or gouache if you prefer, and experiment with different colour combinations.

figure 27
The Celtic interlace bookmark, which you make in this project, is on the right.

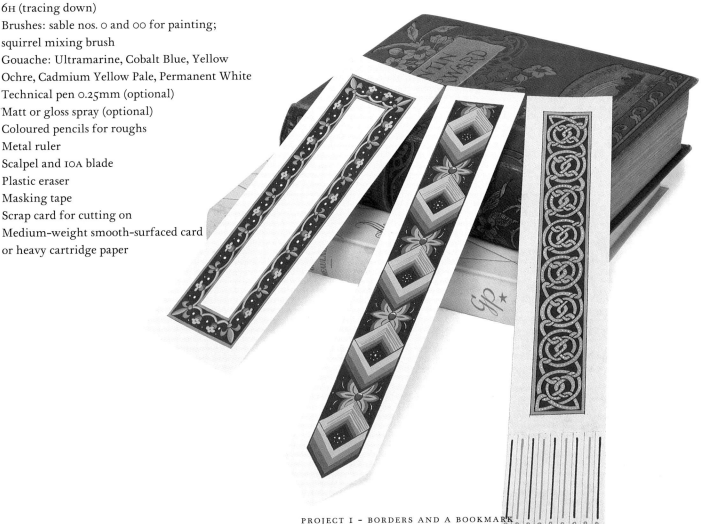

PROJECT I - BORDERS AND A BOOKMARK

45 mm

figure 28, *left*

| | | | |
|---|---|---|---|
| 2 modules (end twist) | @ 23 mm | 46 | |
| 6 modules | @ 21 mm | 126 | |
| Margin at each end | @ 10 mm | 20 | |
| Fringe | | 48 | |
| | | | |
| Total length | | | 240 mm |

figure 29
Tracing accurately with a fine pen.

240 mm

figure 30
Colouring in the pattern roughly.

figure 31, *below*
Interlaced pattern with end twist.

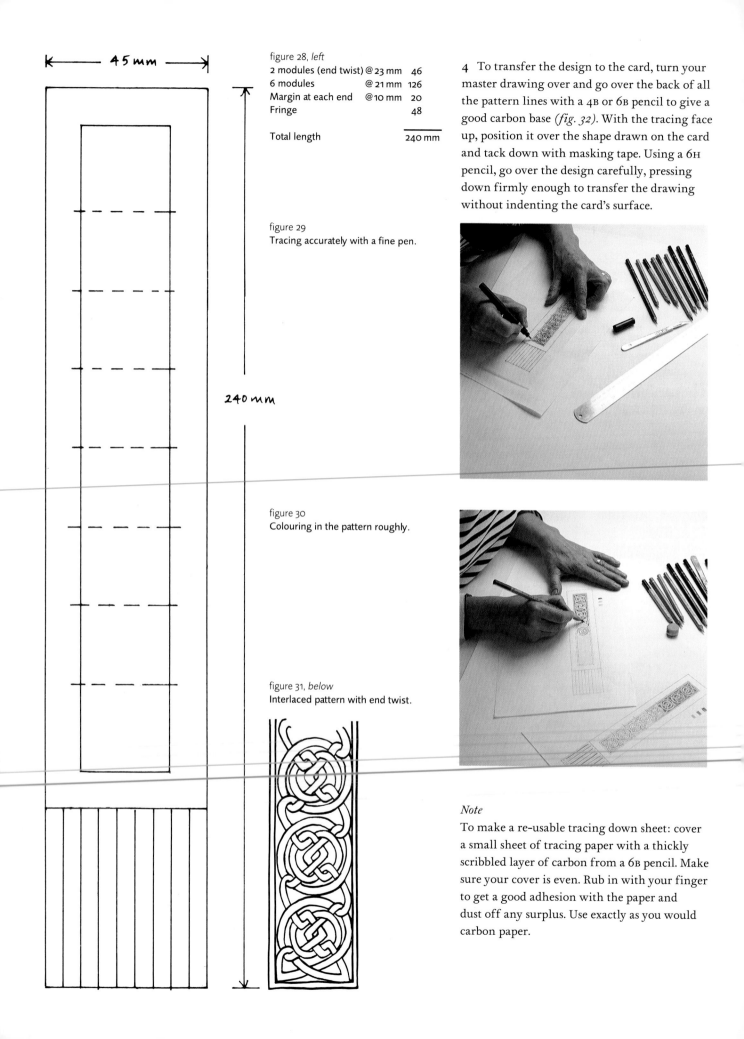

4  To transfer the design to the card, turn your master drawing over and go over the back of all the pattern lines with a 4B or 6B pencil to give a good carbon base (*fig. 32*). With the tracing face up, position it over the shape drawn on the card and tack down with masking tape. Using a 6H pencil, go over the design carefully, pressing down firmly enough to transfer the drawing without indenting the card's surface.

*Note*
To make a re-usable tracing down sheet: cover a small sheet of tracing paper with a thickly scribbled layer of carbon from a 6B pencil. Make sure your cover is even. Rub in with your finger to get a good adhesion with the paper and dust off any surplus. Use exactly as you would carbon paper.

**5** With diluted waterproof ink and fine nib, go over the drawing again, using the bevelled edge of a ruler to keep the long lines straight *(fig. 33)*. This will give a good, clear edge which you can paint up to. Remove any stray carbon marks carefully with a clean eraser. Any wobbly lines can be corrected at the next stage.

**6** Mix up the colours with the squirrel brush, adding Permanent White to Cobalt Blue and

brush. Hold the ruling pen against the ruler or set square wrong side up, to avoid bleeding of paint under the edge. Place tiny white dots down the centre of the interlace *(fig. 35)*.

**8** To prevent any possible transfer of colour from bookmark to book page, you can seal the colour by spraying the surface with a matt or gloss spray before trimming out. Clear adhesive film can be used but is tricky to place success-

figure 32, *far left*
Using a 6B pencil on the back of the master drawing to give a good carbon base.

figure 33, *left*
Strengthening the pencil lines with diluted ink.

figure 34, *far left*
Painting in the pattern.

figure 35, *left*
Adding the finishing touches, including the white dots.

Cadmium Yellow to Yellow Ochre for contrast with the Ultramarine background. Use the no. 0 sable for the interlace and the 00 for filling in the tricky bits of background. Paint up to the ink lines, but not over them *(fig. 34)*.

**7** Go over the outline with undiluted ink and a fine nib, a technical pen or a no. 00 sable brush with black paint. Add lines on the fringe with a ruling pen filled with paint from the mixing

fully because it is prone to air bubbles and ridges over a painted and therefore uneven surface. Repeated use also lifts the film from the cut edges of the fringe.

**9** Trim the bookmark on a piece of scrap card, using a sharp scalpel and metal ruler. If the bookmark has not been sprayed, place scrap paper over the surface to protect it. Press down firmly to prevent the ruler from slipping.

To transfer a narrow strip border with corners, follow Steps 1 and 2 above, drawing out the top and one side of the design using a re-usable tracing down sheet *(see page 46)*. Transfer half of the design to the card.

Turn the tracing over, place it over the other half of the drawn border shape and complete the image. Continue from Step 5 .

With this method, the need for accuracy in drawing and measuring your design is paramount, although adjustments can be made before you ink over the design before painting.

figure 36
Suggested borders for experiments:
top, with calligraphy centre, for cards
bottom right, ideas for bookmarks.

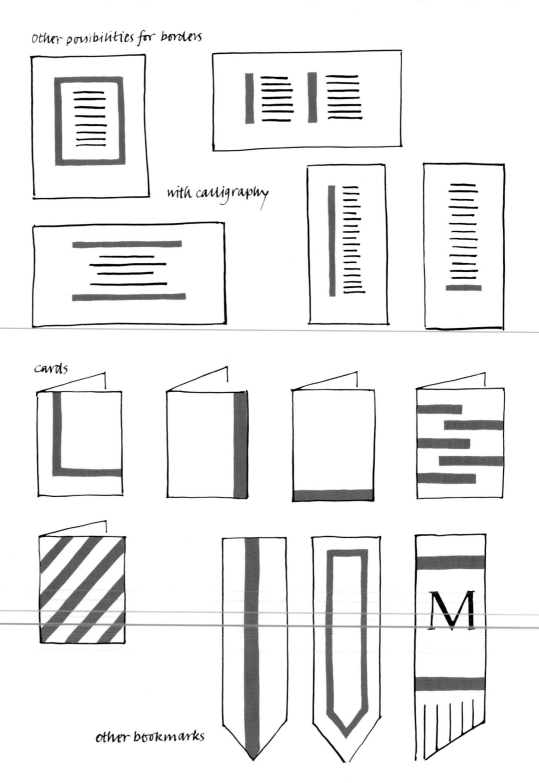

ILLUMINATION AND DECORATION FOR CALLIGRAPHY

# PROJECT 2
## PAINTED AND DECORATED INITIALS

First study the forms of the versal letters on the worksheet on pages 36-7. When you are familiar with them, practise writing them without the double rules, using only a base line. This will enable you to judge the letter height by eye alone and it will avoid a mechanical appearance.

figure 37
Methods of using versals.
Set the capital within the text, with the first few lines indented to the height of the capital.
    The capital becomes more prominent sitting half in the margin.
    Set entirely in the margin, the capital is the dominant feature of the design. Capitals can be used as blocks of text for the opening lines of a book or broadsheet.

The letter may be written with a pen and filled in with a brush. Time spent practising drawing and painting straight lines with pen and brush is never wasted.

figure 38  Decorative capitals.

Versals have spaces in the centre of uprights or the bows of curved letters and these spaces lend themselves to decoration. Always remember that letters should be readable and any decoration should not diminish this. The purpose of illuminated letters went a stage further than simple versals. They draw attention to the beginning of new chapters, for instance. They can take up a large part or even all of the page, or be placed in the margin (*fig. 37*).

At its simplest, the decoration of a capital letter may be a flourish at the end of a stroke or a curve turning into a loop or bud. Different periods used different styles, so refer to historical sources or look at figure 38 for ideas.

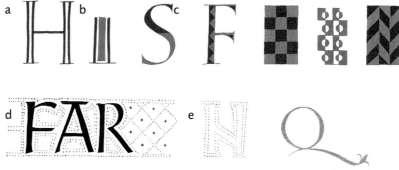

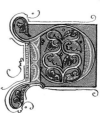

figure 39
Ideas to experiment with:
a  A simple hollow letter.
b  The centre of the letter filled with a contrasting colour, leaving white space between.
c  Counterchanged colours and interchanged diaper patterns; also useful for borders and backgrounds.
d  Outline with dots or make the letter shapes with dots (*see Lindisfarne Gospels, page 8*).

e  Capital written in shell gold (*see page 68*) or gold paint, for test purposes.
f  Capital in box. Patterned background to a plain coloured or gilded letter could fill only the counter-spaces or be used all round the letter. Outlining with black ink and a fine pen gives clarity.
g  Capital with filigree decoration.

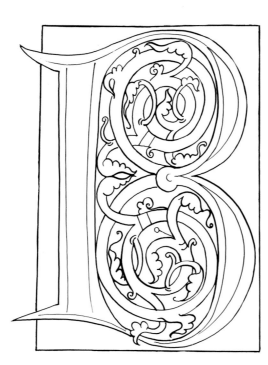

figure 40
Outline of original for tracing.

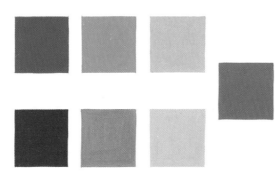

figure 41
Paint in the gold.

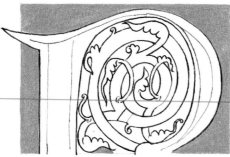

figure 42
Base colours and tones.

## MAKING AN ILLUMINATED LETTER
### Materials
Basic equipment *(see page 17)*
Waterproof black ink
Fine-pointed flexible nib
Pencils: HB, 4B or 6H, 6B
Brushes: nos. 0 and 1 sable for backgrounds,
00 sable for outlining, mixing brushes
Gouaches: Gold, Cobalt Blue, Zinc White,
Scarlet Lake, Oxide of Chromium, Cadmium
Yellow Pale, Lamp Black
Tracing paper
Handmade paper

### Work plan
1  Trace the original or trace an enlarged
photocopy of it *(fig. 40)*. Transfer it to the
writing surface with a 6H pencil and a carbon
sheet *(see page 46)*. Allow plenty of space all
round the image.
2  Go over the pencil outline with dilute
waterproof ink.
3  Mix gold gouache and paint in the outer
background with a no. 1 sable. Work quickly
wet into wet, without allowing the paint to dry
before you have finished one area, to give an
even coverage *(fig. 41)*.

   To avoid smudging the paint, work from
top left to bottom right if you are right-handed,
vice versa if you are left-handed. Keep the area
under your painting hand protected with a sheet
of clean paper.
4  Mix a suitable quantity of the base colours
red, blue and green (Oxide of Chromium +
Cadmium Yellow Pale) to a creamy consistency
*(fig. 42)*  and lay the red background within the
letter with an 0 sable *(fig. 43)*. Cover the palette
with cling film to keep the paint moist.
5  Make the middle and light tones for red and
blue by adding the base colour a little at a time
to Zinc White in separate palette wells. Working
this way round controls the colour strength.
Check the tonal values with the swatches *(fig.
42)*, then lay the lightest tones first and allow
to dry *(fig. 43)*.
6  Apply the middle tones next *(fig. 44)*,
followed by the darkest, which includes the
lettershape itself, using the base colour alone.
When all the colour has been applied and
allowed to dry, outline the letter and the

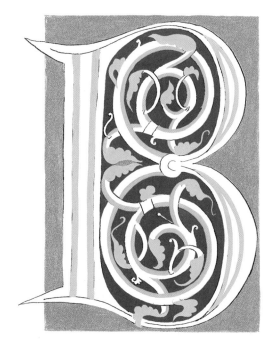

figure 43, *far left*
Paint in the red background and light tones.

figure 44, *left*
Paint in the middle and dark tones.

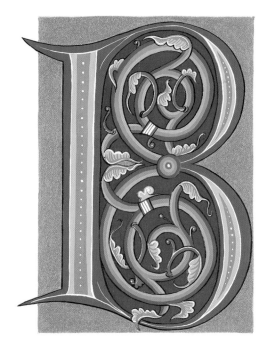

figure 45
Add white highlights to complete.

decorative elements with black gouache and a no. oo sable or fine nib and black ink. This takes practice and a steady hand, but it does tidy up any rough edges on the painting and also sharpens up the details of the design.
7 Finish off *(fig. 45)* by adding the white highlights with Zinc White and an oo sable. This too takes practice to keep the line even and fine, but it adds liveliness to the finished piece as well as giving definition between the tones.

When devising your own decorated letters, work out the design in rough form first and plan your colour scheme. You may find that you need to alter the order of this procedure of placing tones, depending on the design and decorative details. Your rough will help you to sort this out.

# PROJECT 3
# GREETINGS CARD

This project incorporates a decorated initial and a border, based on traditional sources and coloured versals. These are less austere than those on page 36 but use the same proportions. The project also uses the techniques of painting and writing with gouache *(see page 42)*.

## Materials

Basic equipment *(see page 17)*
Layout paper for roughs
Good-quality paper for finished card –
Arches 135gsm, for example
Gouache: Ultramarine, Cobalt Blue, Alizarin Crimson, Scarlet Lake, Zinc White, Havannah Lake (for outlining)
Brushes: no. 3 sable for large areas, nos. 0 and 1 for filling in letters and intricate spaces, no. 00 for outlining and hairlines, mixing brushes
Waterproof black ink and fine nib for underlining
Bone folder for scoring and folding
Ruling pen

Variations on this project's simple greetings card.

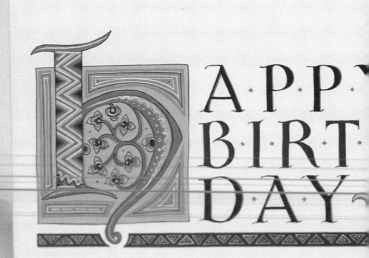

## Work plan

Either make your card to fit a standard-size
envelope or make an envelope to fit your card
(*see page 55*). Alternatively, make an envelope
out of coloured paper to tone with the colours
of the card, even if it is standard size.

1  Rough out your design in pencil on layout
paper, making thumbnail sketches to show the
various permutations in the format (vertical or
horizontal) most suitable to your idea, working
towards a balanced layout (*fig. 46*).

2  Put down an idea of the style and size of
your illuminated letter and wording (*fig. 46*),
and the decoration you wish to incorporate.
Use coloured pencils to visualise quickly how
colour affects the design.

3  Draw up a workable-sized rectangle on
layout paper. Choose the most promising
design and rough out in pencil the space to be

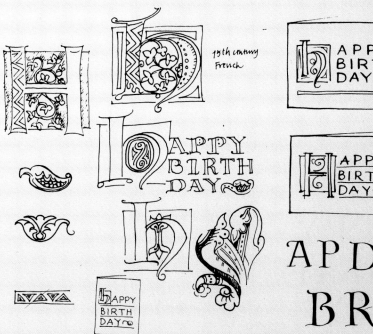

figure 46
Thumbnail sketches.

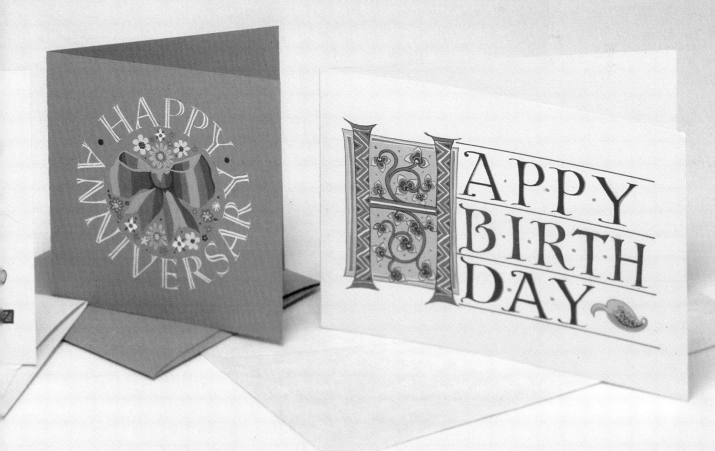

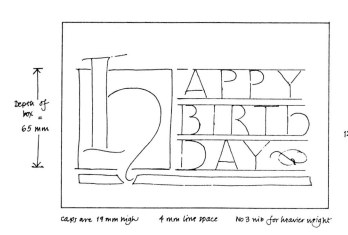

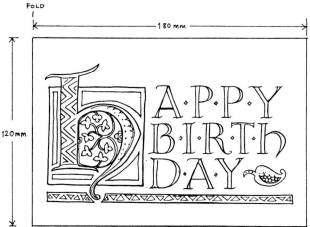

Depth of box = 65 mm

caps are 19mm high    4 mm line space    No 3 nib for heavier weight

FOLD

180 mm

120mm

# APPY BIRTh DAY

occupied by capital and lettering. Write out the wording in non-waterproof black ink on another sheet of layout paper, using a Mitchell no. 3½ nib, and use this to gauge the final height of the capital and surrounding box *(figs. 47 and 48)*. Enlarge the design to fit the space, with reasonable margins, using your draft lettering and capital letter as reference *(fig. 49)*.

5  Tack the card or paper to the drawing board with masking tape and draw out the size, allowing a good margin all round. Transfer the design to the card and rule up lines for the wording. To ensure the letter spacing is right, you may prefer to draft the words in pencil first. Go over the outline of the capital with dilute waterproof ink prior to painting.

figure 47, *top*
Rough out the design to working size.

figure 48, *above*
Write out the lettering at actual size and adjust spacing.

figure 49, *top right*
Draw out accurately to size.

figure 50, *right*
Preparing a full-sized colour rough.

figure 51, *far right*
Writing letter outlines.

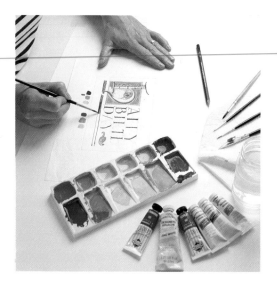

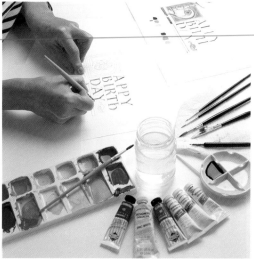

4  Work out the colour scheme accurately, using a photocopy of the layout or a tracing on another sheet of layout paper, and proceed as follows *(fig. 50)*.

Mix up the two base colours and the light, mid- and dark tones by adding base to colour to white. Paint in the design roughly, then experiment with decorative patterns and tonal overlays on spare paper; you could cut these out and place them over the original to assess the general effect and balance of colour.

If in doubt, always keep colour schemes simple *(see Colour principles, page 39)*.

6  Using the pre-mixed base colours, outline the letter shapes *(fig. 51)* with a Mitchell no. 3½ nib, and fill them in with an no. 0 or a 1 sable. When this is dry, paint in light, mid- and dark tones (blue only) on the capital letters, allowing each stage to dry before applying the next, and keeping a sheet of paper under your hand to protect your work *(fig. 52)*.

7  Outline the border shape with a ruling pen and fill in the darkest tone of blue with a no. 1 sable. Outline the capital and decorations with a fine no. 00 sable and Havannah Lake gouache. This would tone in with the colours better than

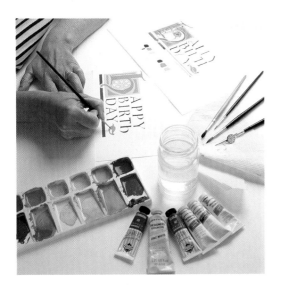

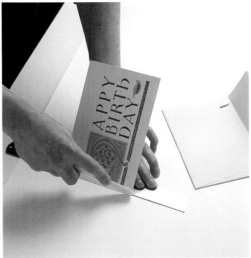

figure 52, *far left*
Painting in the tones. Here, Ultramarine is used with Cobalt Blue, and Alizarin Crimson with Scarlet Lake.

figure 53, *left*
Folding the greetings card.

figure 54
Making an envelope: B is three-quarters of A; C is half of A.

black. Add the white hairline decorations with the oo sable, then the gold dots between the letters and on the background.

8   Trim out with a sharp scalpel and metal ruler on clean scrap card. Mark the centre top and bottom on the reverse side, then score and fold carefully with a bone folder *(fig. 53)*. Remove stray pencil marks with a small piece cut from a plastic eraser, taking care not to spoil the paint surface.

## MAKING AN ENVELOPE
### Materials
Basic equipment *(see page 17)*
Thin card or layout paper
Glue stick
Coloured paper to match or tone with the finished card

1   Make a master template on card or layout paper by drawing a rectangle 8mm (¼in) longer and wider than your finished card. B should be three-quarters the size of A; C half the size of A; D and E 25mm (1in) minimum, though this depends on the envelope size. Round the corners off and trim out if drawn on card *(fig. 54)*.

2   Transfer the measurements carefully to the coloured paper, or draw round the card template. Cut out, score and fold along the dotted lines *(fig. 54)*. Mark the extent of the glueing first, then glue. Take care not to use too much glue – slip scrap paper under the flaps to catch the excess.

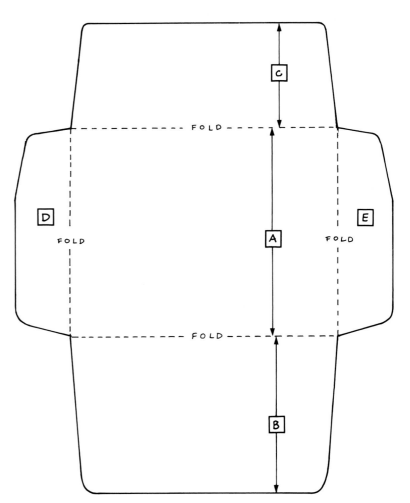

# Design and layout

Design is placing the various elements of the composition – words, pictures, borders and so on – in an arrangement which is attractive and legible, and which conveys the meaning or purpose for which it is intended.

Some people have an intuitive feeling for solving such problems but it is a skill which can be acquired if you follow certain guidelines and learn to train your eye. If you are not sure of your intentions before you begin a piece of work, here are some questions, the answers to which may clarify your ideas.

1   What do the words say and what do you want to demonstrate through them?

2   Why are you executing this piece of work?

3   Who is it for?

4   What form should it take? How the piece of work is to be seen or displayed plays a part here.

5   What is the most suitable script? Legibility may or may not be the prime consideration.

6   What materials will you use?

7   Will colour be appropriate and, if so, which colours?

8   What are the elements involved, and which are the most and the least important? All the projects in this book involve decoration, but this could be a separate element for consideration.

Many of the answers to these questions will arise from studying the words: do they suggest colours, the nature of the decoration or, more basically, the choice of script? Most of us have some association of period and mood where lettering is concerned – 'Gothic' generally suggests the Middle Ages (or Olde English Tea Shoppes!); italic suggests something more modern. Choose a style which is suited to the feel of the words and when they were written, to the meaning they convey and to the scale of the piece of work. Other design considerations are:

LINE LENGTH: determined by the text and purpose of the piece. Follow the natural pauses, such as ends of phrases for line breaks, so that rhythm and sense are not lost.

SPACING: line, word and letter spacing affect the visual texture and can be modified to add emphasis.

VARIETY: can be added by altering the height of the letter, e.g. change the nib size and use the same x height, or vice versa. Colour also plays a part in adding variety.

FORMAT: may be dictated by, for example, the envelope size for a card, a ready-made frame or the size of the paper. The text will be the deciding factor, depending on line length, although this can be altered if appropriate. The most usual shapes are horizontal (landscape) or vertical (portrait) although any shape is usable.

Think about the space around the words. This is important to the overall design and must balance the area of text/illustration. It is easier to deal with this at paste-up stage.

EMPHASIS: sort out the design elements in order of importance/prominence, and decide on the emphasis required for heading, text, decoration and author's name.

MATERIALS: need to be thought about before you start work. A layout which has been worked in black ink on layout paper will look very different in coloured lettering on a textured or coloured quality paper.

How much experiment is involved in your design will depend on how you feel about the words. A simple treatment may be suitable, particularly for a functional piece, or you may prefer a more complicated and personal interpretation, which requires more consideration.

## LAYOUT

This is the real mechanics of design – the putting

figure 55
Thumbnail sketches for layout and format.

Write out text, title, author and so on.

Plan the decoration, decorated capitals, illustrations and borders.

Cut and paste to determine the layout accurately and check the line spacing.

Make a mock-up.

Do colour trials on layout and coloured paper.

Rule up, write out, transfer illustrations, add colour.

Shall I compare

Shall I compare thee
to a summer's day

Shall

down of your ideas on paper. Try this working method *(see also fig. 55)*:

- Put down thumbnail sketches of the ideas, and develop them through to a logical conclusion.
- Write out the piece in your chosen script at a size you are most comfortable writing.
- Draft out panels of decoration, large capitals and the title, following your initial ideas.
- Cut out all the elements, separate the lines of text and arrange them on a sheet of paper, moving them around to find the most suitable and pleasing layout.
- Use the paper measuring scale method *(see page 25)* to give base lines lining up at the spacing you have chosen, then stick all the elements down onto the paper.

## Glues

RUBBER CEMENT: good but messy. Both surfaces need to be coated using a plastic or card spatula. Adjustments are possible as long as the glue has not dried.

SPRAY GLUE: convenient, allows adjustments, but can be a health hazard if not used carefully.

GLUE STICK: easy to use, but repositioning is tricky as it dries quickly.

ROLL-FIX TAPE: available in handy dispensers. The non-permanent sort allows easy repositioning and the adhesive goes where you want it to.

Assess the finished effect by placing a sheet of tracing paper over the paste-up to eliminate the distracting shadows cast by the cut pieces.

## Preparation for work

It is important to think and work your ideas through before commencing a piece of calligraphy. Follow the planning procedure, reject ideas which do not work, improve those which do, refine the quality of the drawing, tune up your writing – and by the time you reach the stage of putting the design on to paper you should be reasonably confident of success.

## Line arrangements

Develop a flexible attitude to layout. First ideas are often good ones, but the paste-up method presents possibilities which might otherwise not have occurred to you.

To help frame the format and balance the text and margins, cut out L-shapes in black card, large enough to overlap and place on the layout. Move them about until you find the best text-to-space ratio *(fig. 56)*.

figure 56
Masking the work to find the best text-to-space ratio.

# Floral borders

In Project 1 *(see page 44)* some ideas were given for using borders in layouts with calligraphy. This project incorporates plant illustration with calligraphy. Two ideas are combined and ways of constructing freer, modern types of borders as well as complex, traditional ones, together with a verse or piece of prose, are considered.

## Layout ideas

Floral borders can be combined with decorated initials, along the lines of the mediaeval Books of Hours, or they can stand on their own in a free, informal interpretation. There are many possibilities for varying the layout in vertical or horizontal format *(fig. 58)*, depending on how ambitious you wish to be.

## Choose your medium

Choose the medium you would like to work in – pen and ink (with or without colour), gouache, watercolour or coloured pencils. Plan your layout with this in mind.

The photographs *(figs. 57 and 59)* show two examples in rough form using the same piece of poetry, with a similar centred format, combined with two types of floral decoration.

I leant upon a coppice gate
When Frost was spectre-gray,
And Winter's dregs made
desolate
The weakening eye of day.
The tangled bine-stems
scored the sky
Like strings of broken lyres,
And all mankind
that haunted nigh
Had sought their household fires.

*Thomas Hardy*

The first version has a semi-stylised drawing of honeysuckle as a repeated motif in a vertical strip, giving a formal feel. The second has a freely interpreted drawing of teazels, which closely follows the indented lines of the text and consequently looks more informal.

## Pen-drawn filigree borders

Follow these instructions for an easy method:

1  Find a 'root' for your growth to start from. It may be a capital letter or a point on a frame

figure 57
Floral borders need not be complicated.

figure 58, *left*
Some layout ideas for floral borders.

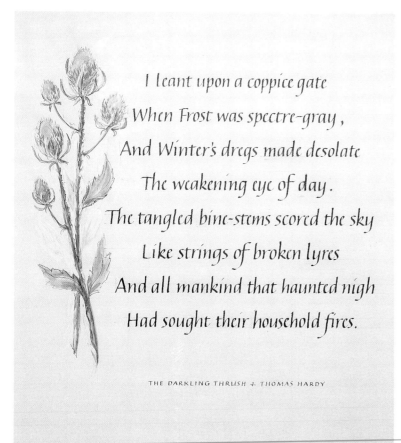

I leant upon a coppice gate
When Frost was spectre-gray,
And Winter's dregs made desolate
The weakening eye of day.
The tangled bine-stems scored the sky
Like strings of broken lyres
And all mankind that haunted nigh
Had sought their household fires.

THE DARKLING THRUSH + THOMAS HARDY

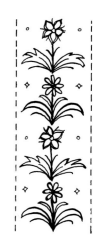

figure 61
Two floral motifs alternated within the border shape.

figure 59
A more informal approach.

figure 60
Adapting filigree borders to a modern style.

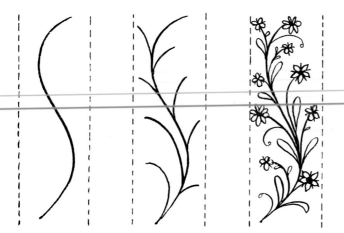

border. The main stem and branches are drawn lightly in pencil within the area you have set aside, shown in dotted lines (*fig. 62a and b*).

2   Add minor branches to cover the spaces evenly, then add flowers, buds and fruit evenly in the spaces formed by the larger curves (*fig. 62c*).

3   The leaves are added all over in every convenient space (*fig. 62d*). Put in leaf stalks and extra tendrils to fill the interspaces; this adds to the overall intricacy. The leaf shape can be varied.

When the design is complete, go over it with dilute waterproof ink as a base for painting and/or gilding, using a fine-edged pen (no. 6). Work this out in rough first, before committing your ideas onto good paper.

You can adapt this design to a modern style by using one or two branching-form plant patterns as a simple repeat up a continuous stem (*fig. 60*).

Another possibility is to consider alternating two floral motifs within the border shape (*fig. 61*), adding tiny dots or diamonds in gold or in a complementary colour for the finishing touch. The design of the flowers need not just be formal or stylised (*see pages 62-6*). You could work in a more naturalistic way with a looser arrangement. This idea might also be used as a decoration for plain versals, which is particularly suitable for modern subjects, combined with italics. Whichever style you follow, consider the space around the work.

Don't cramp the work; let it have plenty of 'air' around it. Try to harmonise the style of illustration with the style of lettering, free or formal, but don't ignore the possibility of contrast. A fine line illustration combined with heavyweight lettering can be effective. Look again at Gothic lettering with filigree borders!

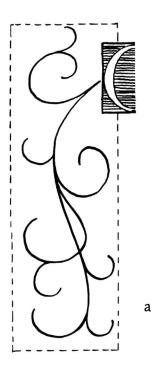

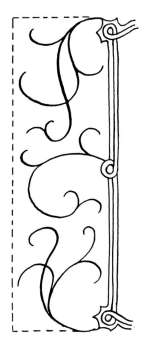

figure 62

a and b
    Draw the main stem and branches lightly in pencil within the area for a capital letter.

c  Add minor branches, flowers, buds and fruit evenly.

d  Add leaves all over.

e  Alternative decorations.

a

b

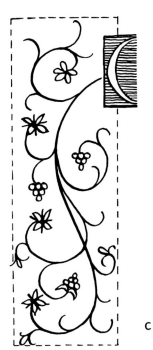

c

d

e

FLORAL BORDERS

# PROJECT 4
# CONCERTINA BOOK

There are many possibilities of subject matter and materials for this little book. You could write out an alphabet in it, a quotation of prose or poetry, or birthday greetings. You may wish to follow a particular theme or idea, incorporating symbols, illustrations and borders on coloured or textured paper.

This project gives you the opportunity to try a looser, more modern approach than the traditional styles of the previous projects.

Work out your design as a mock-up first, planning the pages in paste-up form *(see pages 57-8)*. Sort out your choice of paper, colour of ribbons and writing – contrasting or complementing – before you start work.

I have chosen garden herbs for my subject matter, with pale green text and dark green cover papers. You could use wrapping or other decorative paper with a small pattern in toning or contrasting colours as an alternative for the cover. Gouache or watercolours are suitable for both writing and painting, but consider using a mixture of different media.

## Materials
Basic equipment *(see page 17)*
Good-quality paper for text and cover – Canson mi-teintes 100 and 448m
Wrapping paper or other decorative paper with a small pattern – as an alternative for the cover
Gouache (Oxide of Chromium, Naples Yellow, Ultramarine, Scarlet Lake and Zinc White), watercolours and/or coloured pencils
Grey millboard or very stiff card
Approximately 1m (39in) ribbon 3mm ($^1/_8$in) wide cut into four equal pieces
Waterproof black ink
Rubber cement, PVA glue or white adhesive paste. (Some glues impart too much moisture to paper, which causes cockling and could damage writing or painting. Always test glue on scrap paper)
Cutting mat or scrap card and metal ruler for trimming out
Ox gall liquid to assist the flow of paint onto the textured paper
Bone folder for scoring and folding

The fully hand-crafted book in concertina form has a more modern approach than the traditional styles of the first three projects.

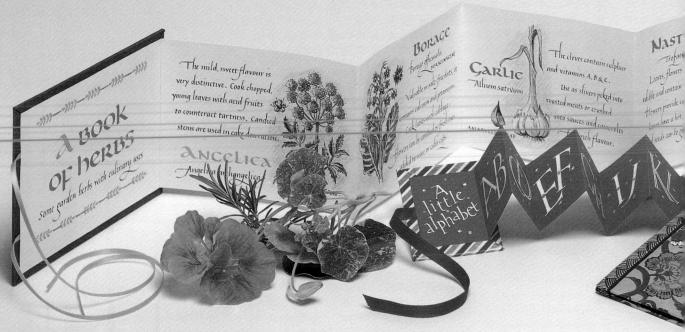

## Work plan

**1** Gather your information together: factual information, poetry or prose quotations, photographs or sketches of the plants – or real plants to draw from. Decide what you are going to include. On a small page size you must be selective so that you do not overload the visual effect. Choose items which give variety throughout the book.

Have in mind a size for your book and the number of pages. The one in this project is eight pages, size 90 x 125mm (3$\frac{1}{8}$in x 4$\frac{7}{8}$in). Make a mock-up in layout paper, following the folding sequence (*fig. 63*).

**2** Make thumbnail sketches (*fig. 64*), varying the layout from page to page to retain interest. Bear in mind that you are making a multi-page book and, while variety is necessary to avoid boredom for both maker and reader, some continuity is also required. A common colour, style of writing, base line for headings or a theme running through the whole book is needed to produce unity, even though each page may be arranged differently.

**3** Having decided on your scripts (*fig. 65*), write out the text, headings, etc. for each page in non-waterproof black ink. Experiment with size, weight and colour to find which work best.

**4** Sort out the decorative elements by sketching the borders and plant illustrations,

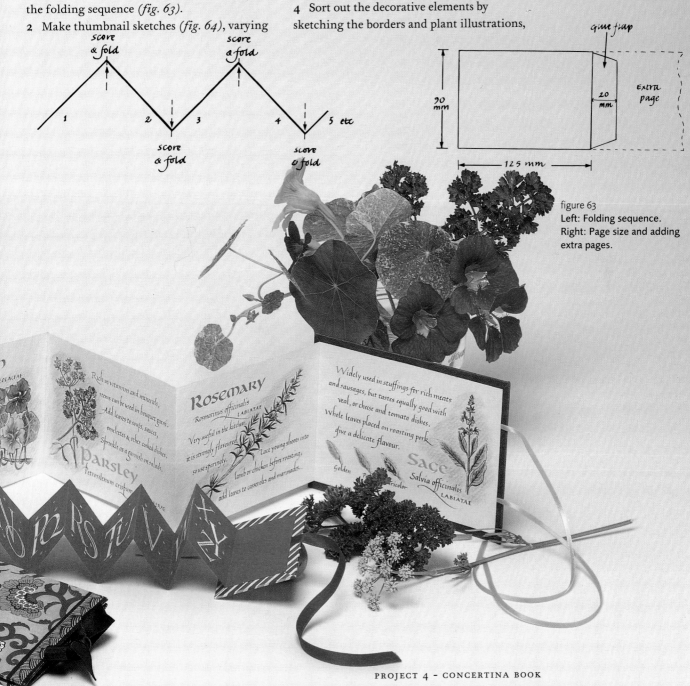

figure 63
Left: Folding sequence.
Right: Page size and adding extra pages.

figure 64
Vary thumbnail sketches from
page to page to retain interest.

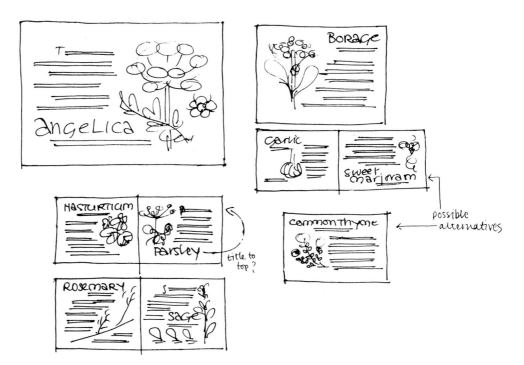

avoid boredom for both maker and reader, some continuity is also required. A common colour, style of writing, base line for headings or a theme running through the whole book is needed to produce unity, even though each page may be arranged differently.

3  Having decided on your scripts *(fig. 65)*, write out the text, headings, etc. for each page in non-waterproof black ink. Experiment

coloured paper as well as on the white layout paper *(fig. 66)*.

Watercolour is ideally suited to a tight, botanically accurate approach. It also works well in combination with ink and coloured pencils for a more loosely interpretive style.

5  Assemble all the elements, cut them out and arrange them on the layout paper mock-up *(fig. 67)*. Some layouts which work as tiny

figure 65, *right*
Sketch layouts for the whole
book to aid continuity. Uncials
*(see page 30)* are shown here,
with a flourished italic and tiny
roman capitals.

figure 66, *far right*
Carrying out colour trials with
the lettering after the lettering
has been drafted.

with size, weight and colour to find which work best.

4  Sort out the decorative elements by sketching the borders and plant illustrations, deciding on the treatment and colouring as you work through. Do colour trials on scraps of your

sketches do not work as well full size, so be prepared to alter the positioning on the page, to rewrite bits of text, or alter colours or redo drawings.

For this project the heading size was altered and the lavender colour from the title page

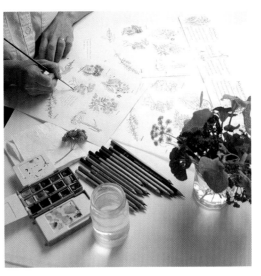

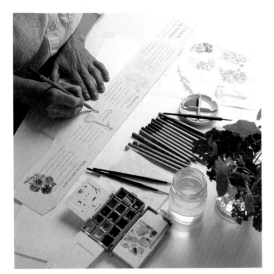

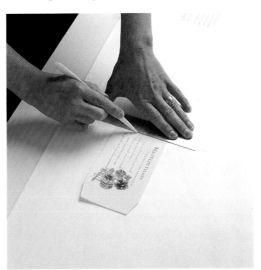

figure 67, *far left*
Finishing the mock-up.

figure 68, *left*
Colouring the flower drawings.

figure 69, *far left*
Colouring the illustrations
after completing the writing.

figure 70, *left*
Scoring the paper before
folding and finishing.

substituted for the green on the pages which had green plants and no flowers. A lavender-coloured pencil was used to provide a background wash to highlight the drawings and to provide another link through the pages.

6  When you are satisfied with the result, stick all the pieces down with a glue stick, checking that the line spacing is correct and consistent. It is worth taking the trouble to sort out details like this now, to avoid mistakes and frustration if things go wrong on the finished piece.

7  Draw all the illustrative matter accurately on tracing paper. This can be photocopied and used for colour experiments, as well as the master from which to transfer on to the coloured paper (*fig. 68*).

8  Draw up the pages on coloured paper, leaving a 20mm (³/₄ in) allowance for joining on the extra pages. Trim out, mark the reverse side accurately, rule in base lines for the text and transfer the drawings as described on page 46.

9  Mix up sufficient gouache for the whole book and complete the writing, one colour at a time, finishing with the italics in black ink. Rinse the nib frequently in water and dry with a tissue to avoid a build-up of ink or gouache, which would spoil the flow and the crisp edges you want to achieve.

You should also take care not to spatter the paint on to the paper when putting colour on to the nib with a brush, although small blobs could be worked into the design. If this happens, scratch the paint off carefully with the point of a scalpel, rub gently with a cut piece of eraser, and burnish lightly with your fingernail.

10  Using dilute waterproof black ink and a fine nib, go over the illustrations, adjusting the shapes around the writing if necessary, and erase all pencil marks carefully. Paint one page at a time (*fig. 69*), using your original sketches or

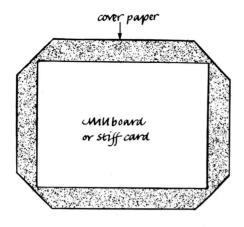

cover paper

Mill board
or stiff card

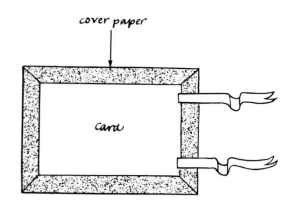

cover paper

card

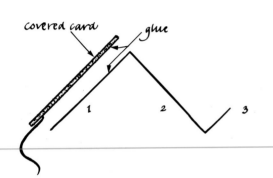

covered card        glue

1        2        3

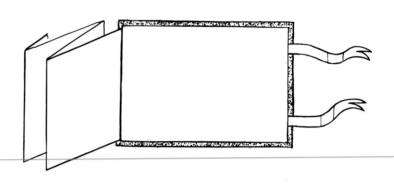

figure 71
Top: Making covers.
Bottom: Attaching pages
to covers.

photographs as reference and protecting the
work with clean paper all the time.

II When the writing and painting are finished,
score the paper on alternate sides *(fig. 70)*, fold
(using a rule and bone folder) and glue on the
extra pages.

If you have made a mistake or spilt paint
or ink on any of the pages, redo them on fresh
pieces of paper, allowing glue flaps on either
side, then cut and stick in as appropriate to
replace the damaged ones.

## Book covers and assembly

Front and back covers: cut two pieces of
millboard or stiff card 7mm (¼in) larger than
the page size, using a metal ruler and scalpel on
scrap card. Measure and cut out two pieces of
cover paper 15mm (½in) larger than the card,
cutting the corners at 45 degrees *(fig. 71, top)*.

Centre the card on the paper and glue.
Fold in the overlaps and smooth down, paying
attention to the mitred corners (more glue
may be necessary here). Attach two lengths
of ribbon to each cover with a dab of glue,
making sure that the positions match on
either side.

Attach one of the covers to each of the
first and last pages by spreading a thin film
of rubber cement on both of the reverse sides.
Allow 30 seconds to dry. Cover the written
surface with clean paper and burnish with
the bone folder.

# CHAPTER SIX ~ TECHNIQUES
# Gilding

Gilding is truly the 'icing on the cake'. Used in a tasteful way, it makes a page sparkle with life as it reflects the light and it can give focus to important features of your design. Study traditional manuscript book initial letters to understand this point.

There are different methods for flat and raised gilding. Some are simple and use few materials; the best is time-consuming but gives wonderful results. All of the methods require patience and willingness to persist through trial and error, taking notes of the work done, the materials used, the time of day and prevailing weather conditions.

That last item may surprise you, but the weather can be crucial to the success of work with gold leaf. If the air is too dry, the gold will not adhere reliably. Avoid working in a

figure 72
**Gilding equipment**
1A Flat psilomelanite burnisher, for burnishing initials and high polishes on large surfaces
1B Agate dog tooth, for burnishing up to edges, round corners and over small areas
1C Pencil point, for indenting surface patterns through glassine; also directs gold leaf precisely to edges and corners
2 Piece of old, washed silk for polishing gold
3 Gilder's knife for cutting loose gold leaf on the cushion
4 Gilder's cushion. The parchment screen acts as a draught excluder for the suede-covered cushion
5 PVA medium
6 Gum ammoniac size
7 Palette for mixing gesso
8 Gesso cut into small pieces ready to use
9 Loose gold leaf – real gold hammered into thin leaves between pieces of leather. Colours vary – the $23\frac{1}{4}$ carat is a classic shade, suitable for illumination
10 Gilder's tip for picking up pieces of gold after cutting. Draw the tip over the hair on the crown of your head to produce static, then lift the gold off the cushion
11 Transfer gold leaf – real gold attached to tissue
12 Fine short-haired sable brush for applying shell gold
13 Shell gold
14 Brush, quill pen and metal nib for applying gesso
15 Gum ammoniac pieces

centrally heated room or on a hot day. Best results are obtained in the early morning, before the atmosphere becomes too dry.

## GOLD PAINT

If you are a beginner, or want to plan where to use gold in your layout, gold gouache will give acceptable results. It is available in different shades, so choose the one which complements the colours in the decoration.

Gold gouache is easier to use than gold inks and, if mixed to the right consistency, can be applied with a brush to give a good, flat gold over large areas. Mixed thinly, it will flow in a dip pen if applied to the nib with a brush. You cannot burnish gold paint.

## SHELL GOLD

Shell gold is genuine powdered gold mixed with gum into a small tablet. It was once sold in mussel shells, hence its name, but now comes in plastic saucers – not as picturesque, but still expensive. Shell gold is available in different shades: yellow, red or green.

Applied with a brush or pen, it dries to a matt finish which may be polished gently to a dull shine. It reflects less light than gold leaf. Patterns or dots may be indented into the surface, using a hard pencil or a pointed burnisher through glassine or crystal parchment. These indentations catch the light, adding extra brilliance.

### Method

1 Add a few drops of distilled water to the edge of the tablet to moisten it.
2 With a short-haired no. 0 or 00 brush, mix the gold to the consistency of ink, tilting the palette to prevent the mixture thickening.

Experiment with the amount of water added. You must juggle flow with covering power to suit the method of application – pen or brush. Too much water results in patchiness; add too little and the mixture will not flow from brush or pen.
3 Mix frequently during use to distribute the pigment evenly and to reduce evaporation. Keep the palette covered when not in use.
4 When the work is dry, polish it with a piece of silk, or give the work a gentle rub over with an agate burnisher.

You can heighten the effect by carefully painting shell gold on top of yellow ochre.

Shell gold is expensive, so keep a separate brush for it and rinse it out in a screw-top bottle containing distilled water. The gold can be recovered and re-used.

## GOLD LEAF

The following methods use gold leaf, which cannot be applied directly onto any surface as it needs a base or size onto which it can be laid. For best results use a writing surface which is smooth and not too absorbent. A textured or soft surface may soak up too much gum and not leave enough for the gold to adhere to.

### Gum ammoniac

Gum ammoniac can be bought ready made, though it is also easy to prepare. It is derived from the sap of an umbelliferous plant and it has a rather unpleasant smell!

### Materials

Small glass jar with lid
Larger glass jar with lid
Piece of fine-knitted nylon (tights, old linen teatowel fabric)
Gum ammoniac
Non-acidic preservative – chloroform or rectified spirit

### Method

1 Remove seeds, stone and other impurities from the gum ammoniac and break it into pea-sized pieces.
2 Soak the pieces in just enough water to cover them in the smaller glass jar, stirring occasionally. Leave to dissolve for at least 8 hours. You can speed up the dissolving process by putting the jar into a pan of hot water. The gum melts in minutes and can be strained as soon as it cools.
3 Attach the piece of nylon to the top of the second jar with a rubber band and sieve the mixture through. The mixture will be glutinous, with the colour and consistency of single cream, though it does not smell as appetising! Do not force the remaining sludge through the mesh, or the result will be spoiled by impurities.
4 Add a minute amount of watercolour paint, enough to see the writing or decoration, and a

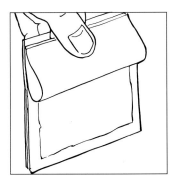

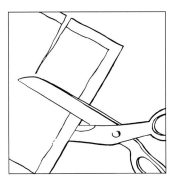

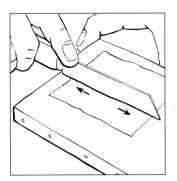

figure 73
Laying gold leaf.

a  Open the book downwards, holding the top firmly, to avoid the leaf crumbling into unusable heaps.

b  Cut with grease-free, sharp scissors through backing paper or

c  Hold the book next to the gilder's cushion and turn it carefully, face down, to place the gold onto the cushion. Cut the leaf in half, using a slight sawing motion. Lift and repeat to cut into smaller pieces as appropriate.

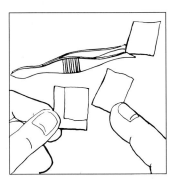

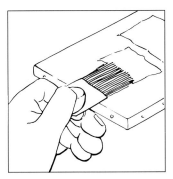

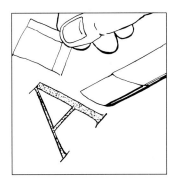

d  Lift with tweezers and fingertips or

e  Lift with a gilder's tip, having run the bristles over your hair to produce some static.
   Alternatively use a large paint-brush (no. 8 sable) or squirrel mixing brush.

f  Holding the gold ready, breathe several times on the gesso to make it tacky. A breathing tube of rolled blotting paper prevents condensation on the work.

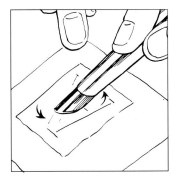

g  Lay the gold onto the gesso, pressing down firmly through the backing paper and/or glassine.

h  With a psilomelanite (or haematite) burnisher, rub down through the glassine, using a gentle circular motion, pressing into the edges. Tuck the edges of the leaf over the gesso with the dog tooth or flat edge.

Repeat f to h until the gesso is covered.

You can burnish gold on gesso without glassine, using increasing pressure, to achieve a brighter finish. Leave it overnight, then clean off any surplus gold with a clean, soft brush.

similar amount of preservative. Store in a well-labelled jar in the refrigerator and keep out of the reach of children. The preservative should prevent the formation of mould, but if any does form skim it off and sieve the mixture again.

5  Stir well before using to ensure the gum is well distributed, and apply with a pen or a brush. If you use a brush, wash it in warm water afterwards to remove all traces of gum or it will harden and become unusable.

### Applying the gold

1  Allow half an hour for the gum ammoniac size to dry before applying the gold (see fig. 73).
2  Breathe onto the size through a tube of rolled blotting paper with two or more good breaths to make the size tacky. The blotting paper prevents condensation dripping on to the work.
3  Press the gold leaf firmly down onto the size, taking care not to twist it. Rub down through the backing with a burnisher. If the gold does not stick the first time, repeat the breathing/ application process until the surface is covered. Burnish gently through glassine.
4  Remove the surplus bits of gold with a clean brush.

Extra layers of gold add to the brilliance. The only burnishing possible is a gentle polish with a piece of silk. As with shell gold, the surface may be patterned or dotted.

### PVA gilding medium

PVA (polyvinylacetate: a glue) gilding medium is like a modern version of gum ammoniac and may be bought ready made, but you may have some PVA painting media already and most of these are suitable. Experiment and find which works best for you. The PVA will take a high burnish if laid on thickly – this is best done with a brush, as success with a metal nib requires persistence and the addition of a little water to improve the flow.

### Method

With the work on a flat surface, apply the PVA with a brush or pen. To raise the base, add another layer when the first layer is dry. If applied very thickly, the PVA is liable to dry with a ridge down the centre – this could be incorporated into the design.

### Applying the gold

1  When the size is completely dry, breathe and apply as for gum ammoniac.
2  Place glassine over the letter and rub with the burnisher, using the edge or a hard pencil to tuck the gold right into the edges and corners. As you may have to apply another layer, do not rub the surplus gold off.

If you apply more gold, burnish again through glassine, then on the surface of the gold – very gently at first, gradually increasing the pressure. Burnishing is best done with a hard, shiny surface such as glass or melamine under the work. Rub the burnisher clean on a piece of soft silk.
3  Brush away the surplus gold. Check that the edges are sharp and that the gold is not patchy. Re-apply the gold if necessary.

Rinse your brush out promptly and wash it thoroughly with warm, soapy water when you have finished. It is not advisable to use your best sable brushes for this.

### Gilding on raised gesso

This is a traditional method which has changed little since mediaeval times. It involves laying gold leaf onto a firm base of plaster size which is raised slightly from the writing surface (fig. 74). The gold can then be burnished almost to a mirror finish. This method of gilding gives the best results when done well, but it is not the easiest of the three techniques.

Gesso cannot easily be bought ready made, so you will need to know how to make it for yourself. The recipe below is the result of extensive research by many scribes and has been successful over the years, but it is not easy. The method is long and not always reliable in results, as they can be affected by damp, cold, excessive heat or imperfect gesso. Nor does it necessarily work in the same way twice, although conditions appear to be the same, as even experienced gilders will confirm.

When preparing batches of gesso, take notes of the time of day, quantities used, the weather and the length of time taken for grinding. Keep the notes for future reference – it would be frustrating if one day you discovered a wonderful example among the results of your

experiments and you did not have the faintest idea how to repeat it!

## Materials and equipment

16 parts slaked dental plaster
6 parts white lead (powered lead carbonate)
**NB This is highly toxic and easily inhaled or ingested. It is also a cumulative poison so great care must be taken when using and storing it, particularly when it is dry because then the dust can be inhaled. Titanium dioxide is an acceptable alternative**
2 parts sugar (rock candy or raw brown coffee sugar)
1 part fish glue, as pure as possible. Seccotine is suitable
Armenian bole or other non-gritty pigment for colouring
either: a sheet of ground glass, minimum 47cm (18in) square and a 7.5cm (3in) diameter heavy glass muller
or: a large pestle and mortar and spatula kept exclusively for this purpose
2 palette knives
Silicone non-stick paper
Small salt spoon (US 1/4 teaspoon), used only for making gesso
Distilled water

## Method

1 Crush enough sugar to make 2 spoonfuls of fine powder. Scrape it on to a piece of paper. Wash and dry the glass and muller.
2 Measure out all the ingredients onto clean, dry glass. Spoonfuls of powder should be scraped level but not packed down. Keep the heaps separate so that you can check you have the right number of each.
3 Put the measure of glue in the centre of the glass or mortar, scrape all the powdered ingredients on top and add a tiny amount of Armenian bole.

If using a pestle and mortar, tip out the sugar after grinding and measure 2 spoonfuls onto silicone paper. Rinse and dry the utensils. Put the glue into the pestle and tip the powder on top.
4 Add enough distilled water, a little at a time, to mix to a thick creamy consistency. With the glass and muller, finely grind half a teaspoon of mixture at a time in the centre of the glass

for 1 minute. Scrape this onto a clean corner of the glass and continue until all the coarse mix has been ground once. Repeat the process to remove any gritty bits which may not have been ground the first time. With a wetted palette knife, spread the mixture evenly on to silicone paper and smooth it into a small circle. If using a pestle and mortar, grind for about 40 minutes.
5 Put the mixture in a lidded box, or a box covered with a teatowel, to keep the dust off. Leave to dry overnight – the mixture takes from 36 to 48 hours to dry completely.
6 When partially dry, cut into 16 segments with the palette knife. This makes it easier to break off equal parts when you use the gesso.

## Glair

To use the gesso, you must first mix it to a suitable consistency for pen or brush application with glair, which is egg white and water (*see fig. 74a and c*).

To make glair, separate the egg white from the yolk and beat the white until it is so stiff you can turn the bowl upside down and none falls out. Put it into a clean jar with an equal quantity of water, stir and leave covered for 6 to 8 hours. Strain off the froth and it is ready to use. Keep it in a labelled screw-top jar in the refrigerator.

### USING GOLD LEAF (*see also fig. 73*)

Do not touch the leaf with your fingers – it will stick to them. If there are wrinkles in the leaf, smooth them out on the cushion with the gilder's tip or flat blade of the knife.

Gold leaf is very light, and the slightest movement of any sort will send it flying! Before you start work, close all doors and windows, avoid violent movement and don't breathe out too energetically.

One way round this problem is to use transfer gold leaf. The gold is attached to tissue backing and is therefore easier to handle and apply. You only need clean, sharp scissors to cut a suitable-sized piece to lay over your work. Follow the rest of the laying and burnishing procedure as for loose gold leaf.

Note: If a leaf is damaged beyond use, put it in a clean white envelope – you can grind this down to make your own shell gold as follows.

figure 74
Laying traditional gesso.

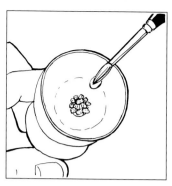

a  Crumble the piece of gesso into an eggcup. Add a few drops of glair or water and leave to soak for 10 minutes, or until it is completely soft.

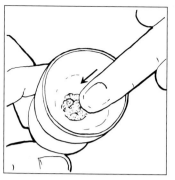

b  Press the gesso down with a finger to expel the air – use the end of an old paintbrush, or wear rubber gloves.

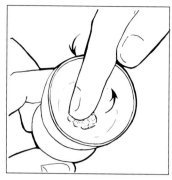

c  Add more glair (see page 71) or 6-8 drops of water, and stir slowly, avoiding making bubbles as these weaken the gesso. Prick large bubbles with a needle – a tiny drop of oil of cloves removes them all. Add more glair or water, a drop at a time, to make a thin, creamy consistency.

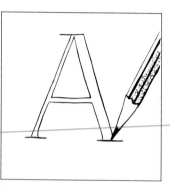

d  Draw the letter or shape for gilding on grease-free paper or vellum, having cleaned it with a light dusting of pumice and a dusting of ground sandarac, both blown clear.

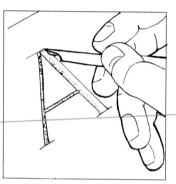

e  Lay the gesso with a flexible pen or quill, flooding the shape with the mixture and teasing it out into the corners. Work quickly, wet into wet, aiming for an even, domed shape over the whole letter. You can use a brush for this stage, but the result is prone to uneven drying and making an even layer takes longer.

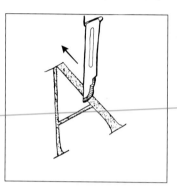

f  Leave to dry for 12 hours. When dry, carefully scrape it smooth with a curved sharp knife (blade no. 15), and tidy up any rough edges.

Grind any left-overs or damaged leaves in a small pestle and mortar with a tiny amount of honey. Add some drops of hot water. The gold will sink and you can pour the water off. Leave the paste plus a drop of weak gum arabic solution to dry in a tiny dish or plastic lid until you want to use it.

## Work plan for gilding

1  Rule up. Trace the design onto the work from the finished rough.

2  Do all the writing first on an angled board.

3  Burnish down the nap (on vellum) or laid lines (if any, on paper) of the area for gilding and painting.

4  Lay the board flat and assemble all the gilding materials ready to hand.

5  Soak the gesso.

6  Mix the gesso with glair.

7  Apply the gesso and leave to dry.

8  Scrape smooth.

9  Breathe on the gesso and apply the gold.

10  Clean away the surplus gold.

11  Paint in large areas of colour.★

12  Add details/modelling.

13  Put in outlines.★

14  Add highlights.

★  Painting up to a gold edge is tricky as the leaf repels the paint. Add a drop of ox gall to the colour, or use a fine pen instead of a brush to add outlines.

ILLUMINATION AND DECORATION FOR CALLIGRAPHY

# GILDING WITH COLOUR

Interesting effects can be achieved by using gold and colour at the same time. Here is a simple method.

## Materials

Smooth heavy cartridge or watercolour paper
Gouache colours
PVA medium
Gum ammoniac
Transfer gold leaf
Burnisher
Small piece of soft silk
Glassine (crystal parchment)
Selection of pens, nibs and brushes (synthetic or mixes)
China palette with circular wells

## Work plan for gold over flat areas of colour

1   Make your 'gesso': measure 5mm ($^1/_4$ in) of gouache, 4 drops of a 50/50 mix of PVA and water, 4 drops of gum ammoniac solution, and 4 drops of undiluted PVA. Use an eye-dropper or the end of a paintbrush for the liquid measures and keep the drops even in size.

2   Mix to a smooth, stiff consistency then lay the gouache in an even layer, avoiding air bubbles, and allow to dry completely – about 20 to 30 minutes. To begin with, experiment by painting stripes, squares or irregular patches of colour in small blocks.

3   To lay the gold, breathe on the colour patches to activate the glue, then press the gold down through the backing with your fingers. Give the

figure 75
Some experiments in gilding with colour.

gold an extra rub down through the glassine with the burnisher.

If the gold does not adhere to the patches after several attempts, add 1 - 2 more drops of gum ammoniac and try again. Note the final numbers of drops used for future reference.

## Decoration

1 Scratch letters into the gold with the back of a scalpel blade or a rounded blade (no. 15).
2 Inscribe gently with a needle or scalpel to make a crosshatch pattern, which reflects light at many different angles.
3 Draw through the transfer gold paper (minus its gold) or through glassine with a 2H pencil or an old ballpoint pen to make indented patterns.
4 Burnish the patches without the glassine. Be gentle at first, then press a little harder for a brighter shine. For a higher polish, add a few more drops of undiluted PVA to the mixture before laying the colour. This gives the gesso more strength and the ability to take more burnishing. Alternatively, you can polish the patches with a piece of soft silk to give the gold a gentle sheen.

## Writing with gold

The method and mixture for writing with gold is slightly different.

1 Mix 2 drops of undiluted PVA with a small amount of gouache and sufficient water to allow the mixture to flow from the nib. This produces 'waterproof' lettering. Write out some words with thick and thin nibs for various effects and allow to dry for 20 minutes.
2 Mix 4 drops of PVA, 6 drops of gum ammoniac and 4 drops of a 50/50 mix of PVA and water. Stir carefully to avoid air bubbles, then swiftly paint over the lettering to produce an even coating, taking care not to smear the paint.
3 Allow to dry, then apply the gold as before.
4 Scratch out in a crosshatch pattern, using even or uneven, straight or wavy lines.

## Further experiments (see also fig. 75)

1 Keep lettering close together, using a broad nib for a heavy weight.
2 Work the sealing coat over a larger area than just the patch over the lettering.
3 Write fine lettering first, apply gold, scratch a pattern, then add heavier brush lettering over the top, or vice versa.

# PROJECT 5
# A CALENDAR OF THE ZODIAC

Many of the techniques already covered in this book are involved in making this calendar, but they are used on a larger and more complex scale. This project will test your ability to draw, to write in gouache and to do simple gilding, as well as your skill in designing and planning individual pages which involve many different elements.

This calendar has one page for each month. For a simpler approach, you could use one page for two or three months, or even just one image for the whole year, with separate calendar strips to be torn off each month.

The first task is to choose your words and images. There is a vast amount of information on astrology so, as with the little book of herbs (*see page 62*), you must be selective.

Incorporating too much information produces a confused layout. On this small page size, 250 x 220mm (9⅞ x 8⅝ in), the same items of information have been used throughout, for continuity. The variation comes in the layout.

One page has been worked through completely and there are sketches and roughs of possibilities for other pages. The rest is up to your imagination and ingenuity.

## Information for each Zodiac sign
Dates
Symbol
Illustration – to form a focal point
Ruling planet and its symbol
Element
Quality – cardinal, and so on
Short descriptive paragraph
Characteristic traits
Gemstone
Flowers and plants
Trees
Herbs and spices
Foods
Calendar – days and dates

## Materials
Basic equipment (*see page 17*)
Automatic pens nos. 3 and 4
Three sheets Fabriano Ingres paper 160gsm
mid-blue – each cuts into six pages. The third
sheet is for colour trials and for a possible cover
Stiff card for backing
Bleedproof white gouache
White coloured pencil for ruling lines
Spring bow compass with ruling pen attachment
Ox gall liquid

figure 76
The finished calendar.

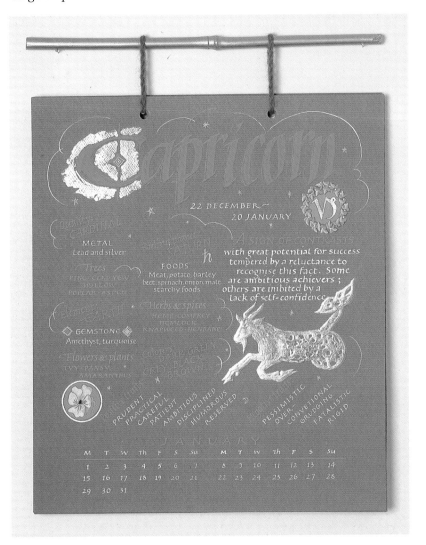

Ruling pen
Coloured embroidery thread or wool to contrast
with or complement the paper colour
A strong twig or piece of narrow bamboo cane
Metal ruler
Double-hole punch
Gum ammoniac and/or PVA medium
Transfer gold leaf (Take care to match the
colours of transfer and shell gold. Ask for
advice when buying, as colours vary)
Shell gold or gold gouache
Glassine (crystal parchment)
Burnisher
Piece of soft silk
Synthetic brush no. o for PVA medium

## Work plan – for each page

1 Collect your information, then decide on
the importance of each element of the design,
not forgetting the date panel which should be
of the same size and in the same position
throughout the calendar for continuity.
2 Work up the design to full size, very
roughly, in pencil, and choose your lettering
styles *(fig. 77)*. The calendar on these pages
uses a combination of italics, capitals and

3 Cut up your original, or a photocopy of it,
and do a rough paste-up over the pencil sketch.
Check that the sizes and positions of items are
correct. Be prepared to alter any item which
seems too large or unbalances the design. When
you are satisfied, tack the pieces down with a
glue stick.
4 Sort out the colour scheme *(fig. 79)*. Instead
of black, which is too sombre, the calendar on
these pages uses a darkish blue paper to suggest
the night sky. This allows colours mixed with
some white to show clearly. The gouache
colours symbolise the four elements:

EARTH
    Venetian Red + Raw Sienna
    *(Vandyke Brown + Venetian Red)*
AIR
    Cobalt Blue
    *(Ultramarine + Scarlet Lake)*
FIRE
    Scarlet Lake + Cadmium Yellow
    *(Cadmium Yellow + Yellow Ochre)*
WATER
    Cerulean Blue + Oxide of Chromium
    *(Oxide of Chromium)*

All are mixed with sufficient white to show

figure 77
Pencil rough and lettering.

figure 78
Colour paste-up.

slightly angled foundational, varying weight,
compression and size, as well as colour, for
added interest.

    Rule up and write out all the text in black
ink on layout paper, using sizes and weights to
suit the space – your pencil rough will be useful
here. Allow space around to cut out for pasting
up. Make roughs of illustrations and other
decorative elements.

up on the blue paper. The colours in brackets
apply to the less important text, and are also
to be mixed with white. All other wording is
written in bleedproof white, which gives a more
opaque line than ordinary white.
5 Write out all the elements again, this time in
colour on layout paper *(fig. 78)*, using the sizes
you established on the black ink paste-up. The
text intended to be in white will still need to be

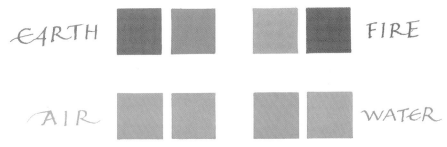

EARTH    FIRE

AIR    WATER

figure 79
Comparison of colour schemes
on white and coloured papers.

FIRE
Quality:
FIXED

•AIR
Ruling planet

WATER
Quality:
MUTABLE

Trees:
ALDER · YEW

Herbs & spices
MINT · CINNAMON

Trees:
WILLOW · ASPEN

Flowers & plants
IVY · PANSY

in black on the white paper. Repeat the cut-and-paste procedure, following your layout and checking the line spacing for consistency.

Steps 3 to 5 take time and patience, but sorting out problems at these stages is preferable to making mistakes on the final piece of work. The trick is in learning when to stop – amending and refining can go on indefinitely. Do take care not to lose spontaneity by overworking the piece, or copying too much from one version to another. If you feel things are not right, put the piece away and start afresh.

When the first page is finished, there is no need to repeat the black-on-white paste-up. Go straight on to use colour, as size and weight of scripts will have been worked out in Steps 2 and 3.

6 Check that your colours work on the blue paper (*fig. 79*). Mix up enough of the four main and secondary colours to complete three pages of each, then pour them into small containers so that they keep liquid – empty 35mm film canisters are ideal. Do the same with the bleedproof white. Adjust the colours

figure 80
Tracing the layout.

figure 81
Burnishing.

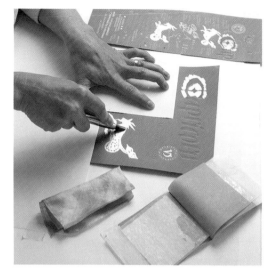

for consistency and opacity, adding white if necessary. You may need a drop of ox gall in the paint to help the flow of colour from nib to paper.

7 Try out the various methods of gilding on the coloured paper if you are not going to use gold gouache.

8 Return to the layout, place a sheet of tracing paper over it to disguise the patch marks, and make a final assessment of the design *(fig. 80)*.

9 Cut out the blue paper to size, tack down the page with masking tape and transfer all markings with a 2H pencil over the prepared trace layout. Rule up all marks accurately to give writing lines, using light pressure with a white pencil; keep the pencil very sharp with a scalpel.

10 Do the gilding first, following the instructions in Chapter 6. If you intend to use gold gouache instead, do the writing first, but you will not be

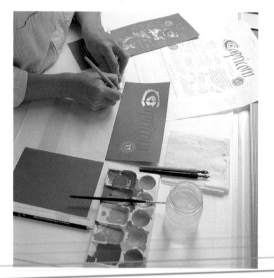

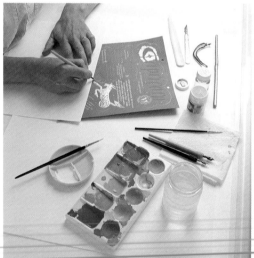

You can also rule it up on the drawing board to obtain an accurate diagram of line spacing, centred lines, positions of illustrations, etc, and transfer it to the blue paper. The carbon paper method *(see page 46)* does not show up sufficiently on coloured paper, so scribble on the back of the traced layout with a white pencil before transferring line markings and illustrations.

able to achieve the same effects as described here.

Apply the PVA medium with an old synthetic hair brush, or even a brush handle, in a thickish layer, teasing out fine lines with the point of a metal nib. Allow to dry and lay a second coat. Again, leave to dry completely – 2 to 3 hours or overnight – before applying the gold leaf, then burnish for a high polish *(fig. 81)*. Incise a

figure 84
Rough paste-up layouts for
other pages of the calendar.

# Libra

23 SEPTEMBER ~ 23 OCTOBER

**BALANCE & HARMONY** is paramount, with freedom from pressure and argument being necessary for happiness. Librans find difficulty in making decisions, give in too easily to pressure.

Positive traits:
DIPLOMATIC • URBANE
ROMANTIC • CHARMING
EASY GOING • SOCIABLE
IDEALISTIC • PEACEABLE

Negative traits:
INDECISIVE • CHANGEABLE
GULLIBLE
EASILY INFLUENCED
FLIRTATIOUS
SELF-INDULGENT

Quality: CARDINAL

GEMSTONE
Sapphire, jade

Trees
ASH • CYPRESS • APPLE
PEAR • FIG

Ruling planet: VENUS

FOODS
Asparagus, artichokes,
wheat, cereals, berry fruits,
grapes, beans.

Herbs & spices
MINT • CAYENNE

Colours: BLUES from pale to ultramarine
PINK
PALE GREEN

METAL
Copper

Flowers & plants
ROSES
ALL BLUE FLOWERS

### OCTOBER

| M | T | W | Th | F | S | Su | M | T | W | Th | F | S | Su |
|---|---|---|---|---|---|---|---|---|---|---|---|---|---|
| 1 | 2 | 3 | 4 | 5 | 6 | 7 | 8 | 9 | 10 | 11 | 12 | 13 | 14 |
| 15 | 16 | 17 | 18 | 19 | 20 | 21 | 22 | 23 | 24 | 25 | 26 | 27 | 28 |
| 29 | 30 | 31 | | | | | | | | | | | |

# Pisces

19 FEBRUARY ~ 20 MARCH

**NATURAL PERVERSITY** is symbolised by the two fishes swimming in opposite directions. Pisceans are charitable, selfless and kind, making the best sort of friend, but they find it hard to face reality & fail to reach their potential.

Quality: MUTABLE

METAL
Platinum, tin

Trees
WILLOW • FIG
TREES NEAR WATER

Ruling planet: NEPTUNE

FOODS
Cucumber, pumpkin,
Lettuce, melon

Element: WATER

GEMSTONE
Moonstone, bloodstone

Herbs & spices
SUCCORY
LIME • MOSSES

Colours: SEA GREEN

Flowers & plants
WATER LILY
ALL GREEN FLOWERS

Positive traits:
IMAGINATIVE
SENSITIVE
KIND
COMPASSIONATE
SELFLESS
UNWORLDLY
INTUITIVE
SYMPATHETIC

Negative traits:
ESCAPIST
IDEALISTIC
SECRETIVE
VAGUE
WEAK-WILLED
EASILY LED

### MARCH

| M | T | W | Th | F | S | Su | M | T | W | Th | F | S | Su |
|---|---|---|---|---|---|---|---|---|---|---|---|---|---|
| | | | | 1 | 2 | 3 | 4 | 5 | 6 | 7 | 8 | 9 | 10 | 11 |
| 12 | 13 | 14 | 15 | 16 | 17 | 18 | 19 | 20 | 21 | 22 | 23 | 24 | 25 |
| 26 | 27 | 28 | 29 | 30 | 31 | | | | | | | | |

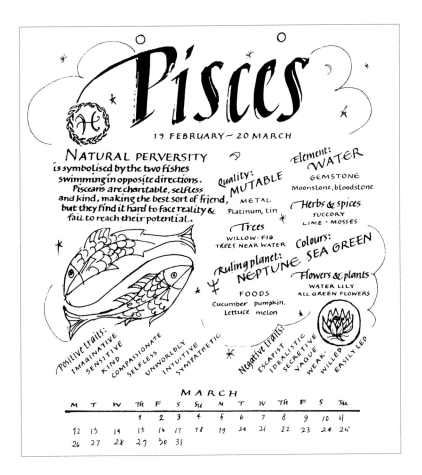

PROJECT 5 – A CALENDAR OF THE ZODIAC

pattern into the surface for the fish scales, hair and so on, using a 2H pencil through glassine.

After gilding on gum ammoniac, scratch a crosshatch pattern with a scalpel point, then buff this and the shell gold stars to a gentle shine with a piece of soft silk. The details and decorative patterns with gold can be varied from page to page.

**11** Do the writing next, using the pre-mixed colours one at a time, finishing with white (*fig. 82*). Paint in the flower and leaves on the roundels, filling the background shape with a lighter tone of the main colour.

**12** Carefully erase any visible white pencil lines

with a cut piece of eraser, then add stars or moons in shell gold or gold gouache, and a few flourishes for a finishing touch, but be careful not to overdo it (*fig. 83*). Try them out first on a piece of spare paper or the tracing paper layout.

**13** Work through all the pages along these basic lines, adding little touches here and there to make each page look different (*fig. 84*).

## To complete the calendar

Gather all the pages, the cover and the backing card together. Using a double-hole punch, make the holes for binding after marking the centres accurately to get all the holes in exactly the same place. If your punch is not a heavy-duty model, do four pages at a time, then punch the card separately.

Using the coloured wool or embroidery thread, plait up two lots of three strands 100mm (4in) in length to make the two hanging loops (*fig. 85*). Sew up one end and secure it to a board with a drawing pin. Plait, then sew up the other end. Repeat to make the second loop.

Slip each plaited length through the holes of the cover, pages and backing and sew the two ends firmly but neatly together.

Slip the twig or bamboo cane (plain or painted as you wish) through the plaited loops (*fig. 85*) and your calendar is ready to hang. The pages will turn easily.

figure 85
Plaited loops and a twig or length of bamboo cane complete the calendar. From top left: sewn ends; ends secured with a pin for plaiting up; sewn second end. Below: plaits slipped through holes and stitched.

# Gallery

The following pages contain work which
shows a wide variety of style and approach
to illumination and decoration combined with
calligraphy. They also illustrate a very varied
and exciting use of techniques and materials.

There are formal pieces done to commision,
others specifically for exhibition, some are
printed items for commercial or private use,
a few are experiments done purely for personal
satisfaction. I hope these examples of skill and
ingenuity will inspire you to pursue your own
studies and practice of this craft.

Gerald Fleuss, 1985.
Detail from London & North
Western Railway panel.
Gouache and shell gold
on Ingres paper.
42 x 30cm (16½ x 12in)

Ecce magi ab oriente venerunt
BEHOLD, THERE CAME WISE MEN FROM THE EAST
Jerosolymam, Dicentes, ubi est
TO JERUSALEM, SAYING WHERE IS THE
qui natus est Rex Judæorum?
KING OF THE JEWS
vidimus enim stellam ejus in
THAT IS BORN, FOR WE HAVE SEEN HIS STAR IN THE
oriente, & venimus adorare eum
EAST, AND ARE COME TO WORSHIP HIM

Matthew ii 1, 2

Gerald Fleuss, 1984.
'Ecce magi ab oriente'.
Watercolour and shell gold
on vellum.
25 X 14cm (10 X 5½in)

Sculpted skyline;
high valleys,
out of reach
transformed
by a rain
of golden sun

Boulder fields
in angular disarray
frosted with
lichens' subtle hues

Below,
glistening lakes,
beads of light
string across
the muted landscape

Sky mountain water
knit
in a harmony
of colour

WEDNESDAY 15 JULY 1992
UNITARIAN CHURCH HALL · VICTORIA ST · CAMBRIDGE
7·15 P·M·

# SUMMER SERENADE

FRED BLATCHLY · CELLO
JEAN DAVIDSON · SOPRANO
CLIVE KING · PIANO

£3·00 FOR ENTRANCE AND PROGRAMME, TO
INCLUDE A GLASS OF WINE OR FRUIT JUICE
DURING THE INTERVAL

*above*
Gerald Fleuss, 1992.
'Summer Serenade'.
Non-waterproof black ink
with scraperboard illustration.
A3 original size

*left*
Gaynor Goffe, 1994.
Words by scribe. Black ink
on Khadi handmade paper,
panels decorated with torn
coloured tissue, gum
ammoniac and gold leaf.
91.5 x 23cm (36 x 9in)

*right*
Ann Hechle, 1993.
'The Four Elements', words
by Joseph Addison. Geometric
signs for the four elements in
raised and burnished gold leaf,
powder gold and watercolour.
Additional patterns and
background using stencils
and a stipple technique.
23 X 13cm (9 X 5in)

*opposite*
Donald Jackson, 1994.
Declaration of intent for S4C
TV's Annual Report. Written in
Welsh on vellum in gouache,
stick ink and vermilion
tempera, with shell gold
decoration. Blue background
to S4C logo, casein-based
gouache. Written with goose
and swan quills.
35 X 21cm (13¾ X 8¼in)

*right*
Donald Jackson, 1993.
Detail of alphabet with bird,
letter height 11mm ($\frac{7}{16}$in).
From a page of the artist's
sketchbook, based on a
12th-century fill-in from
the Metz Pontifical, playing
with the traditional form of
layered illuminating technique.
Raised and burnished gold,
gum ammoniac gilding, shell
gold details. Bird formed from
a smudged fingerprint as
a contrast to the carefully
outlined lettering.

*right*
Donald Jackson, 1993.
Sample of heraldic initials for
Royal documents. Raised and
burnished gold on vellum,
details painted in shell gold
with flourishes added
spontaneously in contrast
to the heavily designed
heraldry. Goose quills used
for the lines, turkey quills
for heavier flourishes.
75 x 70mm (3 x 2³/₄in)

*opposite*
Donald Jackson, 1994.
Illuminated backdrop design
for the cover of the Economist,
Christmas/New Year 1993-4.
Linoleum ink on handmade
paper, gouache gold and silver
leaf on gum ammoniac, shell
gold details.
27.5 x 20.5cm (10³/₄ x 8 in)

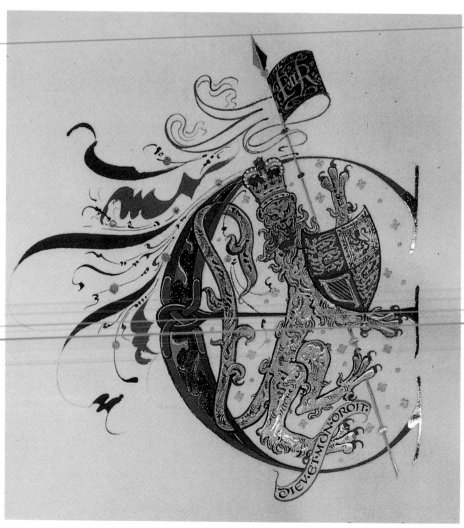

Christine Oxley, 1994.
'Buzzing the Bee', haiku
by Taigi, translated by
Peter Beilenson. Written
in gouache, decorations
in watercolour, watercolour
pencil and shell gold on
Wookey Hole handmade
paper.
19 X 13Cm (7¹/₂ X 5in)

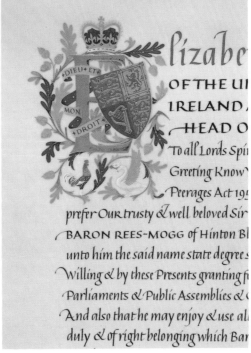

*above*
Joan Pilsbury, 1986.
'Sailing to Byzantium', by
W.B. Yeats. Double opening
of a manuscript book written
in gouache with raised and
flat gilding on dyed vellum.
38 x 48.2cm (15 x 19in)

*left*
Joan Pilsbury, 1988.
Illuminated initial from Letters
Patent conferring life peerage.
Gouache, raised and flat
gilding on vellum.
Height of capital letter
64mm (2½in)

GALLERY

Joan Pilsbury, 1992.
The Prelude, Book II, by
William Wordsworth. Double
opening from a manuscript
book on handmade paper,
with illustrations in watercolour,
bound by Sydney Cockerell.
25.5 x 35.6cm (10 x 14in) open

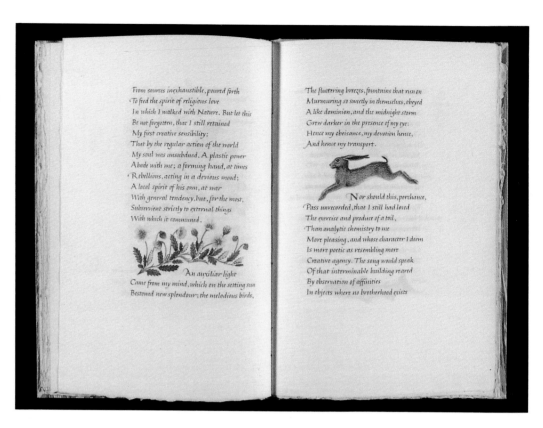

Timothy Noad, 1992.
'Soul of the World', page from
manuscript book 'Hail, Bright
Cecilia'. (From 'Ode to Saint
Cecilia' by Nicholas Brady,
1692.) Original written in
gouache and shell gold on
handmade paper. This version
printed in three colours on
cream matt-coated paper.
25.5 x 40cm (10 x 15¾in) open

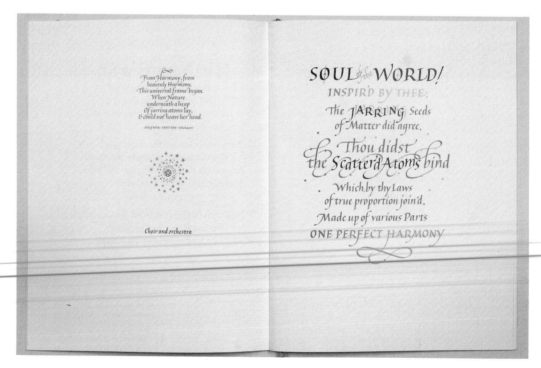

## LYTHAM~ST. ANNE'S

This book was given in memory of Frances Chapman who died in 1958, & Thomas Chapman who died in 1959, by their son, Edward W. Chapman in 1963.

IT RECORDS
the names of people whose ashes are interred in the Rose Garden of All Saints Church, Chingford, "The Old Church."

THE ROSES
in The Garden of Remembrance were given in loving memory of Ernest Howell, by Mrs. G. Howell in 1963.

# Further reading

## Calligraphy

THE CALLIGRAPHER'S HANDBOOK
ed. Heather Child, A & C Black, 1985

HISTORICAL SCRIPTS: A HANDBOOK FOR
CALLIGRAPHERS
Stan Knight, A & C Black, 1984

WRITING & ILLUMINATING & LETTERING
Edward Johnston, A & C Black, 1906
(reprinted 1993)

PRACTICAL CALLIGRAPHY
John Nash and Gerald Fleuss, Hamlyn, 1992

## History

THE ILLUMINATED MANUSCRIPT
Janet Backhouse, Phaidon, 1979

MATERIALS AND TECHNIQUES OF
MEDIAEVAL PAINTING
Daniel V Thompson, Dover Books, 1932
(reprinted by Dover Books)

THE DECORATED LETTER
J J G Alexander, Thames & Hudson, 1978

THE STORY OF WRITING
Donald Jackson, Studio Vista, 1981
(reissued by the Calligraphy Centre, 1994)

## Drawing, painting, colour

PAINTING FOR CALLIGRAPHERS
Marie Angel, Pelham Books, 1984

DRAWING ON THE RIGHT SIDE
OF THE BRAIN
Betty Edwards, Fontana, 1979

BLUE AND YELLOW DON'T MAKE GREEN
Michael Willcox, Collins, 1991

# Glossary

**Angle (of pen)**
The angle at which the pen meets the paper in relation to the writing line.

**Armenian bole**
Red-brown pigment used to add colour to gesso.

**Ascender**
Part of the lower case letter extending above the x height.

**Base line**
Where paper is too absorbent, ink or paint will feather into the fibres, as with blotting paper.

**Bleed**
Occurs when too much ink or paint is absorbed by paper surface

**Body height**
*See x height.*

**Bone folder**
A flat piece of bone (or plastic), round at one end, pointed at the other. Used for scoring and folding paper.

**Broad-edged (nib)**
A nib which produces thick and thin strokes by writing at a constant angle, not by pressure.

**Burnish**
To polish gold to a glossy finish.

**Burnisher**
A tool used to burnish gilding. Can be made of agate, haematite or psilomelanite.

**Capital**
Upper case or majuscule letter.

**Complementary colour**
Each primary colour – red, blue, yellow – has a complementary colour made by mixing the other two.

**Crystal parchment**
*See Glassine.*

**Descender**
Part of the lower case letter extending below the base line.

**Exemplar**
A model alphabet or piece of work for students to study.

**Form**
Abbreviation of letterform, the actual shape of a letter.

**Gesso**
A base for gilding.

**Glair**
Beaten egg white, used as a binding agent in gesso.

**Glassine**
A transparent, non-stick paper used in gilding. Also called crystal parchment.

**Gouache**
Opaque watercolour or body colour.

**Grain**
In a sheet of paper, the direction in which most of the fibres lie.

**Gum ammoniac**
A plant resin. Can be soaked in water to make size for gilding.

**Gum arabic**
A plant resin used to bind colour pigment. Can also be added to mixed gouache or watercolour to improve paint flow and give extra gloss to the colour.

**Gum sandarac**
A plant resin. Ground fine and applied to the paper surface, it is a water repellent. Useful on absorbent paper to prevent bleed.

**Historiated initial**
A decorated capital letter which contains the elements of the text in pictorial form.

**Interlinear space**
The space between two lines of writing, usually measured by the x height.

**Layout**
The arrangement of heading, text, illustration and any other elements of a piece of work.

**Letterform**
The actual shape of a letter.

**Ligatures**
Linking strokes between letters.

**Lower case**
(typographic or printer's term) Small letters or minuscules.

**Majuscule**
Capital letters or upper case.

**Minuscule**
Small letters which have ascenders and descenders, or lower case.

**Monoline**
Letters made entirely with strokes of a single nib width. Also referred to as skeleton letters. They represent the essence of the letterform.

**Muller**
A flat-based ground glass pestle for grinding gesso ingredients on a ground glass slab.

**Nap**
A slight surface texture of some types of writing surface, usually vellum. It prevents the nib from slipping.

**Ox gall liquid**
Add sparingly to mixed paint to improve flow from pen or brush.

**Paste-up**
Assembling cut-up elements of a piece of work, stuck on to paper to finalise the layout.

**Pounce/Pumice**
Fine powder used to remove grease from paper or vellum.

**PVA**
Polyvinylacetate, a glue.

**Quill**
Flight feathers, usually of swan, goose or turkey, cured and cut to make a nib.

**Serif**
The ending of or lead into a letter.

**Shade**
(of a colour) Made by adding black, or the complementary to any given colour in graded amounts.

**Size**
Either a sticky base to which gold will stick, or glue added to paper, or applied to the surface of the finished sheets, to make it less absorbent to ink or paint.

**Skeleton letter**
A letter made without the calligraphic weight of a broad-edged nib. *See also Monoline.*

**Stem**
Main upright stroke of a letter.

**Stroke**
The component of a letter made without lifting the pen from the writing surface.

**Tints**
(of a colour) Made by adding white to any opaque colour. In watercolour, achieved by adding water only.

**Tone**
(or tonal value) The gradations from light to dark, visible in any solid object viewed in light. Best seen by half-closing the eyes.

**Tooth**
A very slight surface texture of paper, which prevents the nib from slipping. *See also Nap.*

**Upper case**
(typographic or printer's term) Capital letters or majuscule.

**Vellum**
Calf skin prepared as a writing surface.

**Weight**
The relationship of the nib width to the height of the letter.

**x height**
Typographic term for the body height of a letter; the main part of the letter, not including ascender or descender.

# Stockists and suppliers

## Paints, brushes, inks

✳ L CORNELISSEN & SON
105 Great Russell Street, London WC1B 3RY

⋈ DALER ROWNEY LTD
Southern Industrial Area, PO Box 10,
Bracknell, Berkshire RG12 8ST

⋈ WINSOR & NEWTON
Whitefriars Avenue, Harrow,
Middlesex HA3 5RH

## Paper specialists

✳ ATLANTIS ART & CONSERVATION
SUPPLIES
146 Brick Lane, London E1 6RU

R K BURT & CO LTD
57 Union Street, London SE1
(will advise on suitability of paper and give
address of nearest supplier)

✳ FALKINER FINE PAPERS
76 Southampton Row, London WC1B 4AR

## Gilding materials

✳ L CORNELISSEN & SON
105 Great Russell Street, London WC1B 3RY

✳ FALKINER FINE PAPERS
76 Southampton Row, London WC1B 4AR
(burnishers, gold leaf)

✳ C F STONEHOUSE & SONS
Millers Lane, Lymm, Cheshire WA13 9RG
(gold leaf only)

✳ WRIGHT'S OF LYMM
Wright House, Millers Lane, Lymm,
Cheshire WA13 9RG

## Nibs for calligraphy and drawing

PHILIP POOLE at L CORNELISSEN & SON
105 Great Russell Street, London WC1B 3RY

✳ FALKINER FINE PAPERS
76 Southampton Row, London WC1B 4AR

⋈ ACCO-REXEL LTD
Gatehouse Road, Aylesbury, Bucks HP13 9DT

## Drawing instruments

BLUNDELL HARLING LTD
Regulus Works, Lynch Lane, Weymouth,
Dorset DT4 9DW

There are many makes of instruments
available; ask for advice in good graphic arts
or drawing office suppliers.

✳ Also does mail order

❋ Mail order only

⋈ Manufacturers and suppliers – ask for the
address of your nearest stockist

## Society of Scribes and Illuminators

The Society of Scribes and Illuminators is the
society which upholds the standards and
traditions of calligraphy and illumination in
the UK, as well as abroad. Details of the
Society and addresses of regional groups are
available from:

The Society of Scribes and Illuminators
6 Queen Square, London WC1N 3AR

# Index